IMAGES
of America
GALVESTON'S
BROADWAY CEMETERIES

Pictured here is a 1921 map of Cahill Cemetery before the last grade raising in the cemeteries. Many names that appear on this map are nowhere to be found in the present-day lots due to grave markers being covered with fill. (Courtesy of the City of Galveston.)

ON THE COVER: The profusion of bright yellow wildflowers makes the month of May a favorite time for photographers and visitors to explore the history hidden in Galveston's Broadway Cemeteries. (Author photograph.)

IMAGES
of America

GALVESTON'S
BROADWAY CEMETERIES

Sawyer —
Remember those
who've gone before
Kathleen Maca

Kathleen Shanahan Maca

ARCADIA
PUBLISHING

Published by Arcadia Publishing
Charleston, South Carolina

Printed in the United States of America

Library of Congress Control Number: 2014958538

For all general information, please contact Arcadia Publishing:
Telephone 843-853-2070
Fax 843-853-0044
E-mail sales@arcadiapublishing.com
For customer service and orders:
Toll-Free 1-888-313-2665

Visit us on the Internet at www.arcadiapublishing.com

*To the memory of my grandparents Juanita Haverfield
Scott and Joseph Graves Noyes, who sparked my
interest in history by sharing stories of the past.*

CONTENTS

Acknowledgments 6

Introduction 7

1. Soldiers and Sailors 9

2. Businessmen and Philanthropists 33

3. Politicians and Community Leaders 61

4. All Walks of Society 87

5. Stone Masons and Funeral Homes 107

6. Effects of Storms 115

7. Restoration and Renewal 121

Index 127

ACKNOWLEDGMENTS

This book would not be possible without the wonderful archives and institutions that generously shared their resources.

I would like to thank the Galveston and Texas History Center of the Rosenberg Library and staff members Peggy Dillard, Carol Wood, and Travis Bible for their time and patience; Catherine Gorman of the City of Galveston Planning Office; Lisa Reyna-Guerro of the Blocker History of Medicine Collections at University of Texas Medical Branch; and Trish Clason of Trinity Episcopal Church.

A special thank-you also goes out to those who shared photographs from their private collections: the Ott family, the Malloy family, Brent Scott, Lisa Smalling, Connie Saculla, and Carolyn Cannon.

Thanks are also due to Chris Smith, who shares my enthusiasm for these wonderful cemeteries and donates so much of his own time to their restoration, and Mike Kinsella of Arcadia Publishing, who was a pleasure to work with during the planning process of this book.

I am also endlessly grateful for the support of friends and family who provided encouragement during the creation of this book, especially John and Kelsey Maca, who had to live with a wife and mother who was most likely to be found wandering in the local cemeteries.

Although only a portion of the amazing stories from these cemeteries are shared here, I hope you will enjoy learning a bit about those who rest there.

A majority of the images in this volume are from the Galveston and Texas History Center at the Rosenberg Library, Galveston, Texas (GTHC) as well as the author's own photography (KSM). Also featured are selections from the University of Texas Medical Branch Galveston, Blocker History of Medicine Collection (UTMB), the City of Galveston, and the private collections of Galveston families and residents.

The following abbreviations are used to identify each grave location. This will be noted in parentheses after each caption, followed by the source of the photograph as noted above.

TE – Trinity Episcopal Cemetery
OC – Old City Cemetery
NC – New City Cemetery
HEB – Hebrew Benevolent Society Cemetery
EV – Evergreen Cemetery
CATH – Old Catholic Cemetery
OL – Oleander Cemetery

INTRODUCTION

Old City Cemetery, established 1839
Potter's Field, established 1839; renamed Oleander Cemetery in 1939
Trinity Episcopal Cemetery, established 1844
Old Catholic Cemetery, established about 1844
Old Cahill Cemetery/Yellow Fever Yard, established 1867; renamed New City Cemetery about 1900
Hebrew Benevolent Society, established 1868
New Cahill Cemetery, established about 1900; renamed Evergreen in 1923

Visitors to Galveston Island often remark on the beauty of a large cemetery they encounter after crossing the causeway onto Broadway. It is a time capsule of history that holds over 6,000 visibly marked burials within a six-block area.

What most do not realize, however, is that the complex is actually composed of seven separate cemeteries plotted together between Fortieth and Forty-second Streets, and Broadway and Avenue L.

The Broadway Cemetery Historic District is the final resting place of heroes of the Texas Revolution, political figures dating back to the Republic of Texas, both Union and Confederate soldiers of the Civil War, prominent local citizens, and more than its share of infamous characters.

One central drive with concrete walks and curbs unifies the look of the grouping of cemeteries surrounded by an iron fence. The divisions between the cemeteries are difficult to distinguish in some areas, marked only by low brick walls.

The burial grounds have a strange and interwoven history, but the beautiful necropolis was not always available to the citizens of the island.

During the early days of settling Galveston, burials were conducted in the large sand dunes that once ran the length of the side of the island facing the Gulf of Mexico. The towering dunes, covered with grass and trees, were a simple solution for family and friends who were responsible for interments of the departed before the age of funeral businesses. Hand-carved markers, often made from salvaged wood, served as headstones for loved ones.

In 1839 alone, 250 victims of a yellow fever epidemic were buried in the dunes along the beach. But the nature of sand is to shift and reshape, and markers were often covered or coffins exposed.

The city's founding fathers, owners of the Galveston City Company, alleviated this situation by donating four square blocks of land in 1839 to be utilized for public burials as part of the Galveston City Charter. Old City Cemetery and an adjacent section named Potter's Field, for those who could not afford burial costs, were established the same year and became the city's first official burial grounds. The location was considered outside of the city limits at that time, a respectable distance from commercial and residential properties.

Many of the bodies previously buried in the sand hills were exhumed and reinterred at the new city cemetery, although others were discovered as they were exposed by the elements.

In 1844, two blocks of this land were deeded to local congregations: one to the Episcopal church and one to the Catholic. These became Trinity Episcopal Cemetery and Old Catholic Cemetery. Both of these cemeteries were enlarged in 1864 when the decision was made to close the section of Forty-first Street that ran between them, and the land was divided evenly.

During the Civil War's Battle of Galveston on January 1, 1863, numerous Confederate and Union soldiers lost their lives, and many were interred in the Old City, Episcopal, and Old Catholic Cemeteries. After the war, a Confederate Potter's Field was created within the existing Potter's Field for veterans with no money or family to provide a formal burial.

Congress also appropriated funds for burials of soldiers and spent an estimated $3,500 on wooden headboards, picket fences, and other improvements by 1868. In addition to the 231 bodies from Galveston, soldiers' remains were brought from Port Lavaca, Green Lake, and Victoria for reinterment. The government took this burial ground out of the national cemetery system in 1869 because it was unable to obtain a clear title to the land, and it soon fell into disrepair.

As a result of the grade raisings discussed in chapter 7, this field now lies hidden beneath Oleander Cemetery.

Old Cahill Cemetery, named for longtime sexton M. Cahill, was established beside the Catholic grounds in 1867 along with a section referred to as the Yellow Fever Yard in response to a tragic epidemic that year that killed 725 people. Many of these burials took place so hastily that the deceased were not identified or their graves marked.

The local Jewish community originally obtained a small section of Potter's Field to use for their burial ground when the six-year-old son of prominent citizen Isadore Dyer died. Through the bequests of Rosanna Osterman, who perished in a steamboat explosion the prior year, the Hebrew Benevolent Society established the city's first private Jewish cemetery in 1868 on land adjoining Old Cahill.

Galveston suffered a tragic hurricane in September 1900, costing the island over 8,000 lives. In response to the need for additional burial sites, two of Galveston's existing cemeteries were christened with new names, and areas from unmarked graves and unused spaces were utilized for burials. Partially in an attempt to give the citizens a sense of renewal, Old Cahill was renamed New City Cemetery, and New Cahill was renamed Evergreen.

Old City Cemetery originally had special sections for the German Lutheran Church, Independent Order of Odd Fellows, and the Protestant Orphans Burial Ground. Evergreen had an Odd Fellow section as well, and all of the cemeteries have numerous masonic gravesites. These section delineations have been obliterated by changes through the years.

The last cemetery to change names was Potter's Field, which was reincarnated as Oleander Cemetery in 1939 during an attempt to expand and renovate the area.

The two buildings visible today in the Broadway cemetery complex are original, built in 1930. They originally served as sexton offices and restrooms for the Old City and Evergreen Cemeteries. An additional sexton office at Hebrew was demolished in 2008, but its concrete foundation can still be seen.

Trinity Episcopal Cemetery once had its own brick receiving vault as well, but it was demolished by Galveston's board of health in 1890.

The seven cemeteries are currently entering an era of restoration, thanks to local volunteers. Those who enjoy the artistic stonework or the history that lies behind them find these burial grounds to be a priceless treasure. The Broadway Cemetery Historic District was officially listed in the National Register of Historic Places in 2014.

One

SOLDIERS AND SAILORS

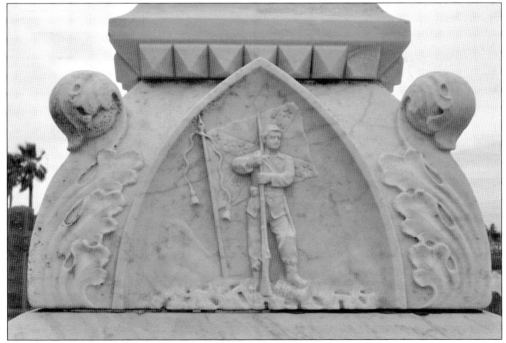

A flag-bearing Confederate soldier is only one of numerous details on General Magruder's monument in Trinity Episcopal Cemetery, which features scenes from four branches of military forces active in the Battle of Galveston during the Civil War. (TE/KSM.)

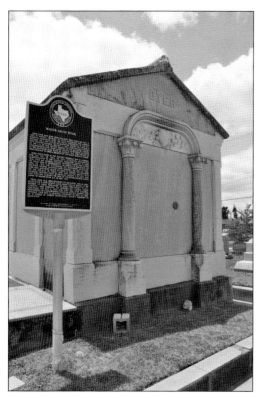

Maj. Leon Dyer (1807–1883) emigrated with his family from Germany to Baltimore, Maryland, in 1812. In 1836, he joined a company of men in New Orleans who embarked for Galveston to join Texas's battle for independence, but arrived two days after the Battle of San Jacinto. He received a commission as a major in the Texas forces and accompanied the guard assigned to escort General Santa Ana to Washington, DC. (HEB/KSM.)

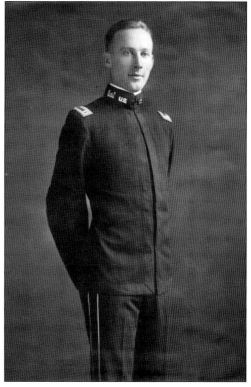

Maj. Edwin Richardson Kimble Jr. (1892–1918) was the first Galvestonian to die on the battlefield in World War I. A West Point graduate and member of the marksman squad, he was selected as an aide for President Wilson. Kimble later died while serving as a military chaplain in Langres, France, with the 1st Regiment, Engineer Corps. Battery Kimble gun battery at Fort Travis, Galveston, was named after him. (TE/GTHC.)

Capt. Charles Fowler (1824–1891) first went to sea from his home in Connecticut at age 14, and became master of his own ship by the age of 21. In 1847, he came to Galveston as captain of the brig *Mary*, returning home in 1851 to wed Mary Jane Booth (1829–1910), pictured below. Once back in Texas, Fowler was commissioned in the Confederate navy and became a member of the JOLO Guard lookout group. He participated in the capture of an enemy fleet and was taken prisoner the following spring. After the war, he became an agent for the Morgan Line and a member of Galveston's board of aldermen. In 1868, he took charge of deepening the water on the inner bar as superintendent of the harbor improvement board and served as the president of the board of pilot commissioners. (Both, TE/GTHC.)

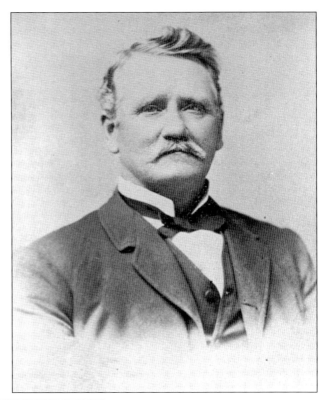

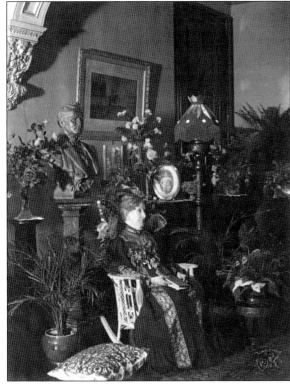

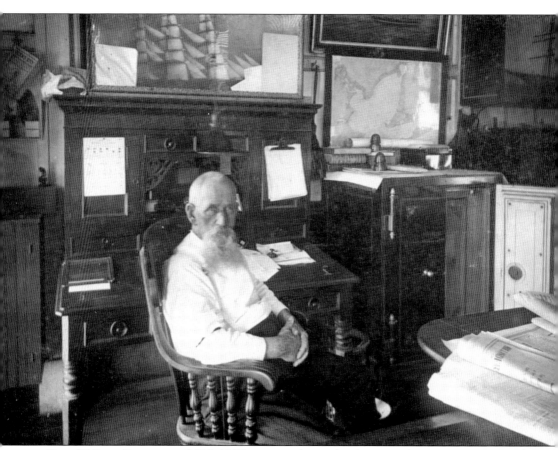

Capt. William Scrimgeour (1836–1919) ran away from school at an early age to go to sea. Within a few years, he became a prominent shipping figure in San Francisco during the Gold Rush and later joined the US Revenue Cutter Service, sailing from Hong Kong to Shanghai and London. He completed three trips around the world, two by way of Cape Horn. After moving to Galveston in 1857, he served as a lieutenant on the Confederate gunboat *General Rusk*, resorting to burning and sinking his ship at Indianola, Texas, to avoid its capture. Scrimgeour was taken to Boston Harbor as a prisoner of war and incarcerated at Fort Warren. After the war, he returned to Galveston and worked for the Morgan Lines as a bar pilot for 30 years. He also served as harbormaster, supervising the docking of all vessels entering Galveston. Heedless of his own health, he nursed scores of citizens during the 1867 yellow fever epidemic. Scrimgeour was a 33rd-degree mason. (TE/GTHC.)

Capt. Thomas Beaverstock Chubb (1811–1890) left home at the age of seven to serve as a ship's boy in the US Navy for four years. He worked various seafaring jobs before being offered an admiralty in the Texas navy in 1836. A member of Galveston's JOLO Guard, Chubb was captured and imprisoned at Fort Lafayette off Staten Island, New York. He served as Galveston's harbormaster from 1882 until his death. (EV/KSM.)

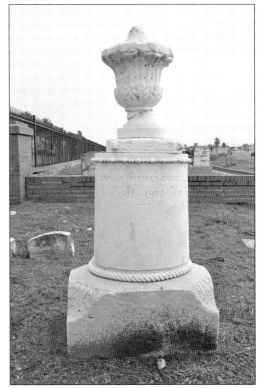

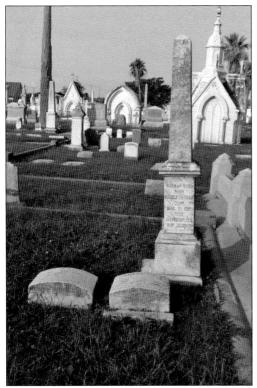

Capt. Norman Hurd (1785–1870) moved to Texas in 1835 after many years in the Merchant Marines. Along with his partner David G. Burnet, he established the first steam-operated sawmill in Texas. In 1840 and 1841, he sailed as purser of the sloop-of-war *Austin* and the schooner *Brutus* in the Texas navy. After his days at sea, he served as deputy collector of customs for the Galveston port. (TE/KSM.)

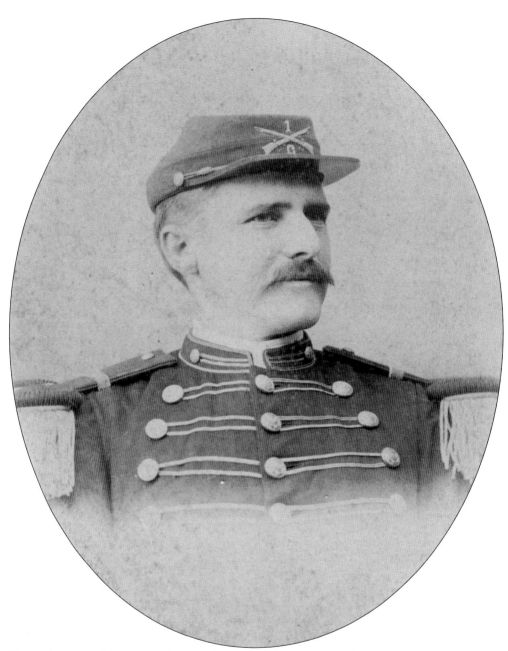

Capt. Edwin King Marrast (1858–1937), born in Alabama, was a colorful and influential military and political figure. Arriving in Galveston on a river steamer from New Orleans at the age of 10, he found work in a cotton office on Galveston's Strand and remained in the cotton-weighing business until his death. The captain was a veteran of the 1st Volunteer Infantry, Company K, during the Spanish-American War and later served as director of recruiting for the Texas National Guard Cavalry. Marrast was a member of the Galveston County Democratic Committee, city clerk, chairman of the 17th senatorial district, and a delegate to state conventions. As one of the organizers of the Sealy Rifles, he also took part in the dedication of the Texas state capitol. His 15-acre farm near Dickinson was fondly called Marrast's Possum Ranch. (TE/GTHC.)

Benjamin Woodard LeCompte Sr. (1839–1891) was a bookkeeper with the Southern Pacific Railway at Morgan's Wharf before becoming an agent with the Galveston, Houston, & Henderson Railroad. He served as an acting adjutant general in the Confederate army and survived a yellow fever epidemic that swept through his unit. LeCompte was a 32nd-degree mason. (EV/GTHC.)

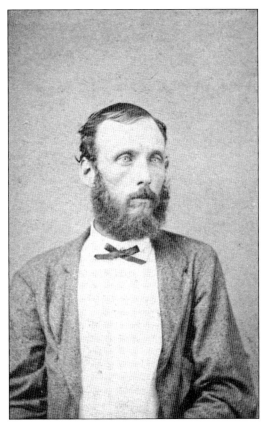

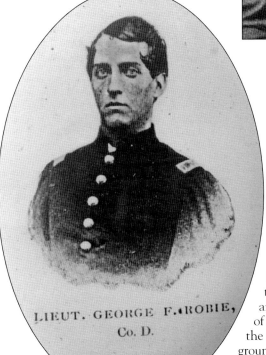

LIEUT. GEORGE F. ROBIE,
Co. D.

Lt. George Frank Robie (1844–1891) served the Union in the New Hampshire Infantry and was awarded the Congressional Medal of Honor in 1883 for conspicuous gallantry in the field. Sleeping on the battlefield's cold, wet ground resulted in a painful case of rheumatism, which he suffered from for the remainder of his life. Robie later worked as a railroad office bookkeeper until his condition forced him to stop. (NC/KSM.)

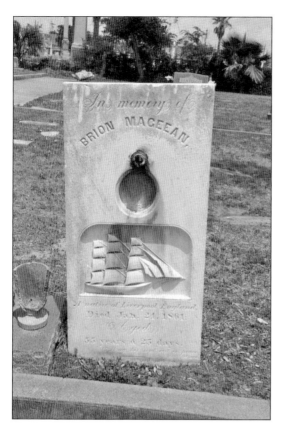

Brion Mageean (1805–1861) moved from Liverpool, England, to New Orleans and then Galveston with his brother James. He worked as a stevedore, or longshoreman, his entire life. Mageean married Galvestonian Julia Ann Dodridge, and together they had two daughters. He was a volunteer with the Washington Hook and Ladder Company No. 1 on Mechanic Street. (CATH/KSM.)

Noah Noble John (1817–1892) worked as a steamboat clerk and survived three disasters without injury: the *Farmer* explosion, the sinking of the *Brownsville*, and the burning of the *Star State*. He was later with William Hendley and Company for over 20 years. John was also president of the Galveston Island Railroad and one of the original stockholders of the Gulf, Colorado & Santa Fe. (OC/GTHC.)

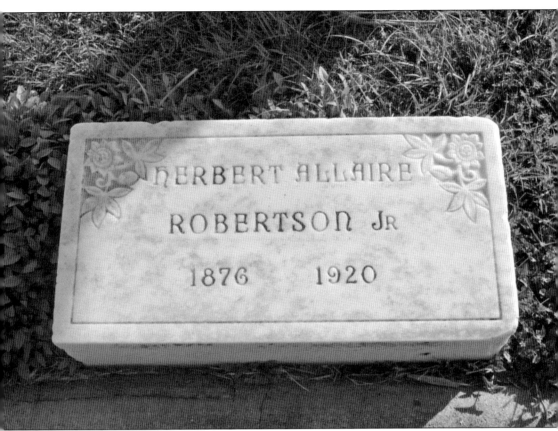

Capt. Herbert Allaire Robertson Jr. (1876–1920) was a respected veteran of the Saint Mihiel, Meuse-Argonne, and Belgian campaigns during World War I. He was commissioned as a captain in the Texas National Guard and would have reported for active duty at Camp Hutchings on the day he died. His tragic death occurred when he failed to heed the warning of a sentry on duty at Avenue T and Thirty-ninth Street at 1:30 am, who commanded him to stop his vehicle. When Robertson drove past the guard, who was standing in plain sight in the road, he was shot. His actions remain a mystery, and he was buried with military honors. Robertson was a member of Harmony Lodge of the Scottish Rite, Sons of the American Revolution, and a director of a local American Legion post. His father, Herbert Allaire Robertson Sr. (1843–1916), shares his burial plot. Robertson Sr. first came to Texas in 1851 and served with the Alabama Cavalry during the Civil War. He returned home to become Galveston's county treasurer. (TE/KSM.)

Robert C. Railton (1830–1898) began working at the island's first foundry in 1848. During the Battle of Galveston, he supervised the recovery of salvage from a Union gunboat, which he bored to be used as guns by the Confederates. He later ran the blockade as engineer on the *Denbigh* before returning to metalwork after the war. Railton was accidently shot as a bystander near a longshoreman quarrel on the wharf. (TE/KSM.)

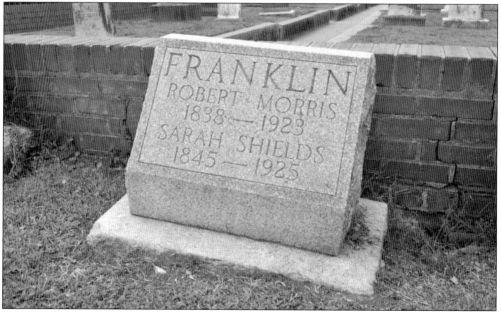

Judge Robert Morris Franklin (1838–1923) served the Confederacy as a cavalryman aboard a makeshift cottonclad ship, an assignment known as a "horse marine." A hero of the Battle of Galveston, he captured the deserter and Union spy Thomas "Nicaragua" Smith. Franklin, who later became a respected judge, was instrumental in planning the city's seawall. The Texas county of Franklin was named for his father, a Battle of San Jacinto veteran. (NC/KSM.)

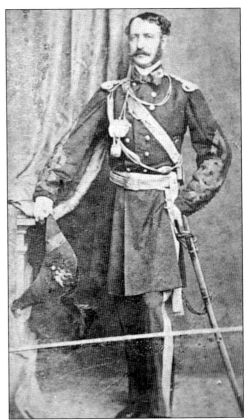

Maj. Gen. John Bankhead Magruder (1807–1871) graduated from the US Military Academy at West Point in 1830. He participated in the Second Seminole War and saw action during the Mexican War, during which his meritorious service resulted in a promotion to lieutenant colonel under Gen. Winfield Scott. At the onset of the Civil War, Magruder resigned from the Army to enlist with the Confederacy as a gesture of loyalty to his home state of Virginia. He excelled at tricking enemy forces into making desperate moves, often giving his smaller troops the advantage. Magruder was reassigned to oversee the Texas, New Mexico, and Arizona district, setting up his headquarters in Houston in 1862. He is credited with the brilliant strategy that allowed the Confederates to regain control of the port during the Battle of Galveston. (Both, TE/GTHC.)

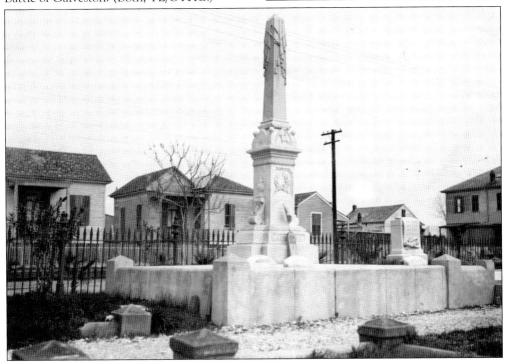

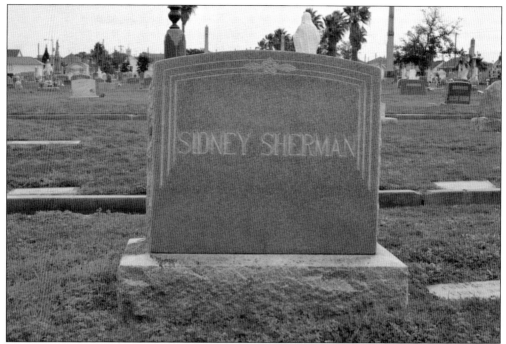

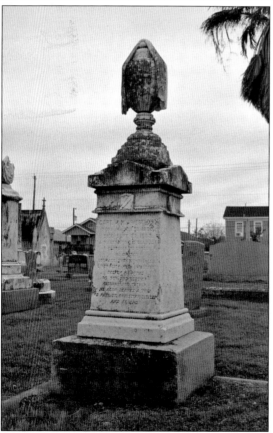

Lt. Sidney Sherman Jr. (1842–1863), the only son of Texas hero Gen. Sidney Sherman, was killed in the Battle of Galveston. Mortally wounded by grapeshot just before dawn, he was carried from his artillery station on the Strand near Tremont Street to the Ursuline Convent where he died in the mother superior's arms. His name appears on his own marker as well as the Confederate monument in the Episcopal cemetery. (CATH/KSM.)

Capt. William M. Armstrong (1830–1863) worked as a clerk in the post office after moving from Mississippi to Galveston with his mother and brother. He founded the firm of W.M. Armstrong and Brother's Great Southern Bookstore and Stationers. As a captain in the Confederate army, he brought rarely seen newspapers from east of the Mississippi to share news with the local community. He died while in active service. (TE/KSM.)

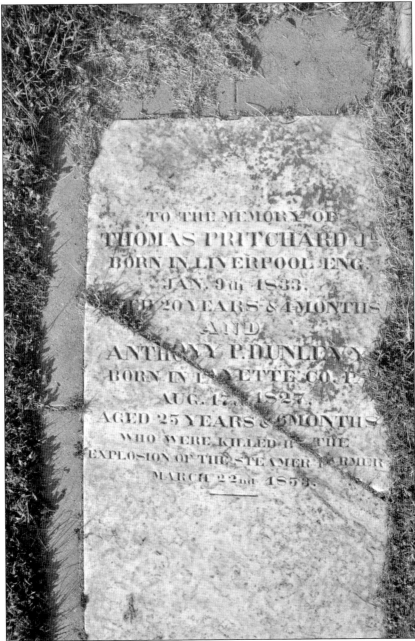

Thomas Pritchard Jr. (1833–1853) and Anthony P. Dunlevy (1827–1853) were killed in the explosion of the steamboat *Farmer*, one of the deadliest maritime disasters of the era. En route from Houston, the ship's boiler burst west of Pelican Island in sight of Galveston, while racing against its rival, the *Neptune*, at 11:00 p.m. Between 30 and 40 people were lost, and fragments of wreckage as small as kindling washed up for miles along Point Bolivar Beach. The two young men's bodies, along with other victims, including the boat's captain, were recovered by neighboring ships over the next few days. Because Pritchard, an English clerk in charge of the ship's safe, and Dunlevy, a carpenter from Pennsylvania, had no family in Texas, it is assumed that community donations or a benefactor paid for their gravestone, which was elaborate for its time. (OC/KSM.)

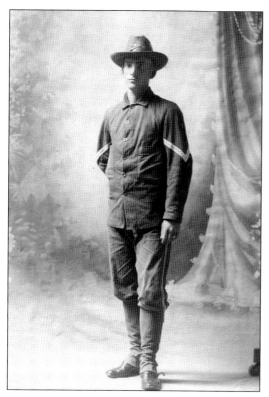

Sgt. Archibald "Archie" Crosby Tucker (1871–1899) was a member of the 1st Texas Volunteer Infantry, Company K, during the Spanish-American War. He mustered into service in Austin in May 1898 and arrived in Havana, Cuba, in late December. The unit participated in numerous battles with Filipino insurgents throughout the first half of 1899. Tucker and his comrades returned to Galveston aboard a steamship on April 2, 1899, and he died of cerebral meningitis five days later. He was one of 14 in his unit who perished from the disease. Tucker was interred in the Episcopal cemetery and moved within the cemetery two years later when his sister Antoinette S. "Nettie" Tucker (1870–1901) died. They rest together under a military headstone. (Both, TE/GTHC.)

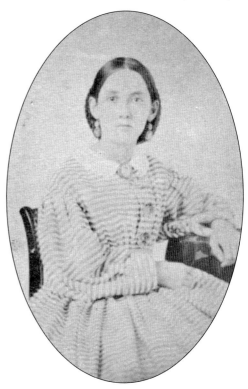

Philip Crosby Tucker (1826–1894) married Mary Cecile Labadie (1838–1873) in 1863. During the Civil War, he oversaw the masonic burials of both Northern and Southern masons in Galveston. He was the grand master of the Texas masons from 1869 to 1870 and was elected grand commander in 1893. The local Tucker Lodge was named in his honor. (OC/GTHC.)

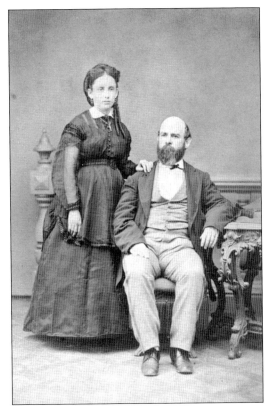

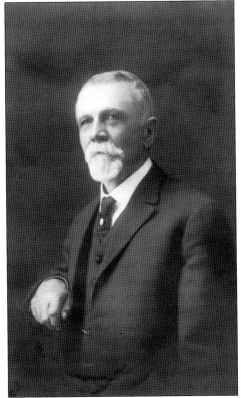

Capt. Joseph Archibald Robertson (1841–1936) was a veteran of the Confederacy who served with Robert E. Lee at Gettysburg. After mustering out of service, he settled in Galveston, where he became a prominent cotton man and the last surviving member of the original board of trustees of the Galveston Cotton Exchange. After overcoming a case of cholera in 1866, Robertson survived to see many Galvestonians lost to yellow fever the following year. (OC/GTHC.)

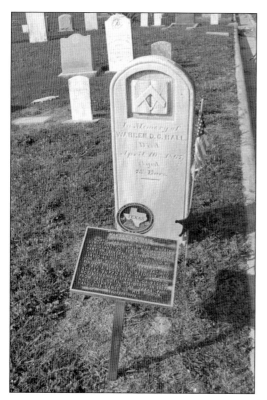

Col. Warren DeWitt Clinton Hall (1788–1867), also called D.C. Hall, served as a lieutenant in the Anahuac Disturbance of 1832 and later took part in the Texas Revolution, acting as secretary of war for the Republic of Texas in 1836. Hall commanded the post at Velasco until independence was won at San Jacinto. A successful lawyer, he was a charter member of the first masonic lodge in Texas. (TE/KSM.)

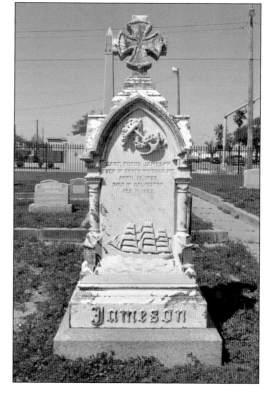

Capt. Rufus Jameson (1820–1882), the master of the ship *Star of the Republic*, sailed the clipper between New York and Galveston in the 1840s and 1850s. In 1853, he and his wife moved to Galveston, where he became one of the first pilots on the Galveston bar. Initially plying a small vessel in the Brazos River trade, he and others soon formed the Galveston Pilot's Association. (EV/KSM.)

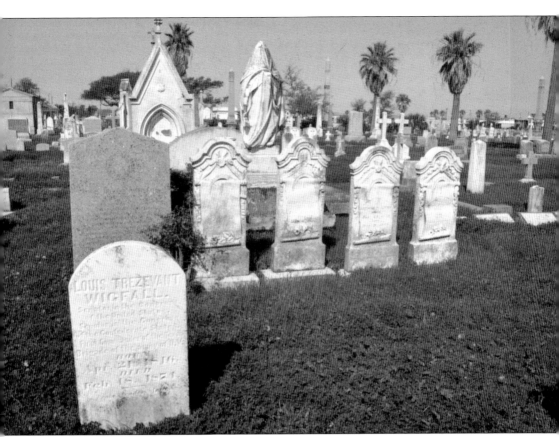

Brig. Gen. Louis Trezevant Wigfall (1816–1874) was a lawyer from South Carolina whose fiery temper was more useful on the battlefield than in the courtroom. In his youth, he participated in duels, wounding one man and killing another. He served as a lieutenant in the Seminole War in Florida in 1835 before moving to Texas. A brilliant orator, he was elected to the Texas House of Representatives and the US Senate, but was expelled in 1861. As a Confederate colonel of the 1st Texas Infantry in 1861, he rowed a small boat under fire to Fort Sumter and negotiated a cease-fire without proper authority. His brazenness resulted in Confederate president Jefferson Davis promoting him to the position of brigadier general and the command of Hood's Texas Brigade. Wigfall resigned from the infantry in 1862 to take a seat in the Confederate Congress. After the war, he fled to Britain where he tried unsuccessfully to incite a war between Britain and the United States. He returned to Texas in 1874 just one month before his death. (TE/KSM.)

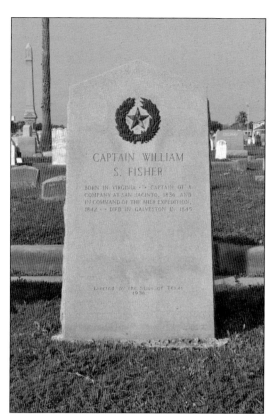

Capt. William S. Fisher (1810–1845) joined the Texas army in 1836 and participated in the Battle of San Jacinto. He served as secretary of war of the Republic of Texas under Sam Houston for one year. Fisher was elected leader of the Mier Expedition, during which a musket ball shot off his thumb. He survived the Black Bean Affair, when Texas prisoners of the Mexican army drew from white and black beans to determine who would be shot. He was released in 1843. (TE/KSM.)

Henry Journeay (1815–1870) served in the Texas army and was a member of the Mier Expedition with Capt. William Fisher. While imprisoned by General Santa Ana in Mexico, Journeay made a violin out of wood scraps, using his pocket knife, a piece of glass, and a file for tools. The violin is displayed at the Texas State Library. After being released, he became a successful mill owner in Galveston. (TE/Saculla.)

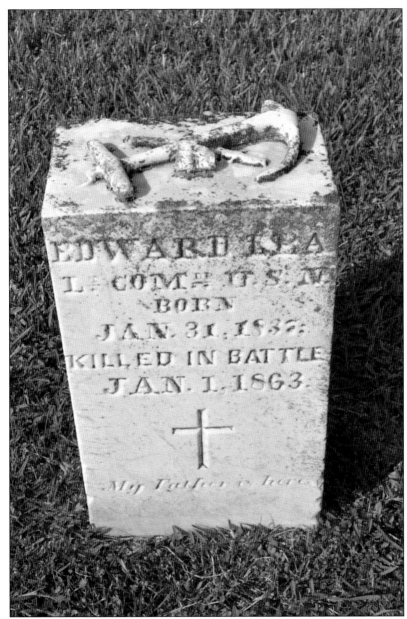

In 1855, Edward Lea (1832–1863) graduated from the US Naval Academy at Annapolis. When the Civil War broke out, his father, Albert Miller Lea, tried unsuccessfully to convince him to join the Confederacy. The younger Lea became first officer on the USS *Harriet Lane*, which engaged in the Battle of Galveston against Confederate troops that included his father, who was serving as a major in an artillery division. After the battle, the father found his son mortally wounded aboard his ship. His son died in his arms, speaking the words, "My father is here." A cease-fire was called, and both Union and Confederate soldiers participated in the masonic funeral of Lea and Union captain Jonathan M. Wainwright. When a relative suggested that Lea's remains be reburied next to his mother in Baltimore, Maryland, Albert Lea refused, stating that his son would have preferred to remain where he had fallen in battle. The destroyer USS *Lea* was named for him, as well as Lea Camp of the Sons of the Union Veterans of the Civil War in Houston. (TE/KSM.)

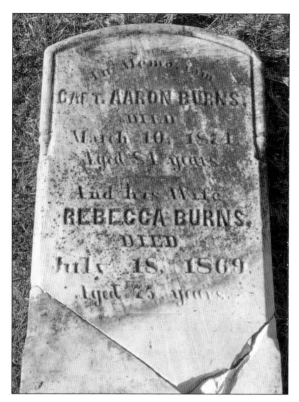

Capt. Aaron Burns (1787–1874), a Pennsylvania native, served with the US gunboat flotilla during the War of 1812. After moving to Texas in 1835, he became a local hero by delivering the famous *Twin Sisters* cannons to Gen. Sam Houston in Harrisburg, Texas, aboard the sloop *Ohio* during the Texas Revolution. The one-time Galveston harbormaster was married to Rebecca Guyer Burns (1794–1869) and was Bolivar's first lighthouse keeper (1852–1861). (OC/GTHC.)

Austin Clay Baker (1832–1898), born in Kentucky, moved with his wife, Susan Summers, to Brenham, Texas, shortly before the Civil War. He enlisted in the Confederate army, serving with Terry's Texas Rangers. After the war, his family moved to Galveston, where he was engaged in the cotton business and then became president and majority owner of the Gulf City Cotton Press. Baker was the second master of Tucker Masonic Lodge. (EV/GTHC.)

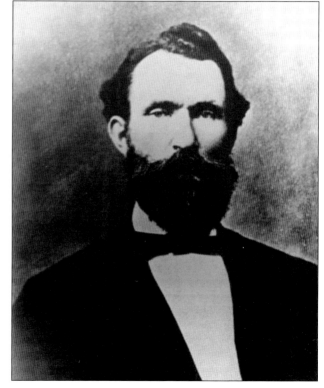

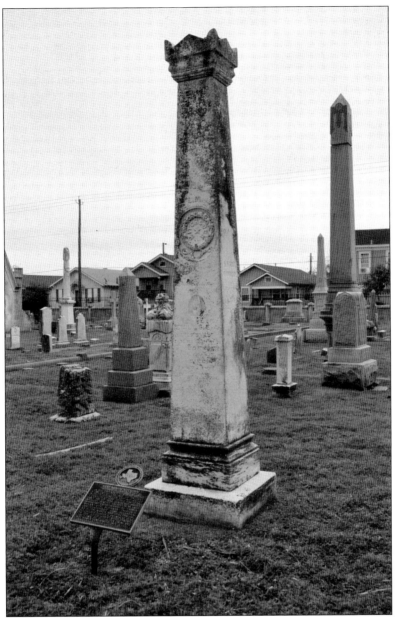

Capt. Lent Munson Hitchcock (1816–1869) became a cabin boy in Connecticut at the age of 14. When he first saw Galveston with his father in 1828, not much existed on the island. Munson later enlisted in the Texas navy and served for two years before settling in Galveston in 1837 and being appointed as a branch pilot. The following year, he became Galveston's first harbormaster, a position he held for 30 years. In addition to owning a schooner that he occasionally chartered to the Texas government, Hitchcock's other business interests included a grocery store, butcher shop, ship's chandlery, the Galveston, Houston & Henderson Railroad Company, the Brazos Navigation Company, and the Tremont Hotel. He served eight terms as alderman of the city and four terms as treasurer, and was appointed acting mayor on several occasions. One of the wealthiest men in the city, he was a charter member of Hook and Ladder Number One, a mason, and a member of the Odd Fellows. The town of Hitchcock is named in his honor. (TE/KSM.)

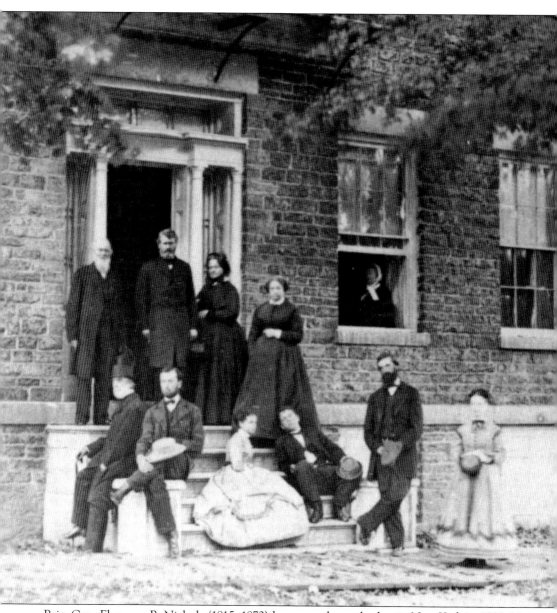

Brig. Gen. Ebenezer B. Nichols (1815–1872) began work as a broker in New York in 1833. He is pictured here in the middle of the top stair, surrounded by family. After bringing a load of lumber to Galveston and being unlucky in its sale, he traveled to Houston to find work. There he joined the Texas Rifles, a group preparing to fight against Indians and Mexicans on the frontier. While in the West, he rose to the rank of major. Upon returning to Houston, Nichols and his partner William Rice founded the mercantile Rice and Nichols and had such success they opened a branch in Galveston. His decision to purchase and expand a brick wharf in the port caused the partnership to dissolve, and the business was renamed E.B. Nichols and Company. Appointed a brigadier general at the outset of the Civil War, he formed a Confederate army regiment, outfitting the soldiers at his own expense. General Magruder made Nichols's residence his headquarters, and Nichols served on Magruder's staff. After the war, the master mason founded the Bank of Galveston and served as its president. (OC/GTHC.)

Frank Antonio Perugini (1919–1942), seen below, and his brother Alexander Joseph "Tony" Perugini (1922–1942), at right, were both seamen first class in the Navy during World War II and stationed together at their request. The men were always close, born on the same day three years apart. They participated together in naval and shore engagements in the Coral Sea, Midway, and the Eastern Solomons. Both were killed when a Japanese destroyer fired a torpedo that struck the gun turret of the USS *New Orleans* during the Battle of Tassafaronda. They were posthumously awarded the Purple Heart, and their parents had a memorial hall constructed on Nineteenth Street in their honor. (CATH/KSM.)

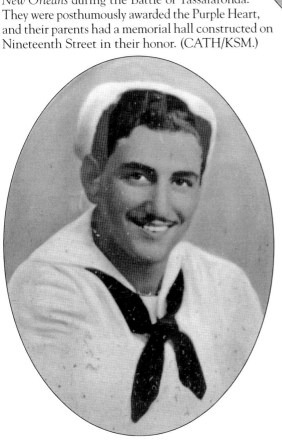

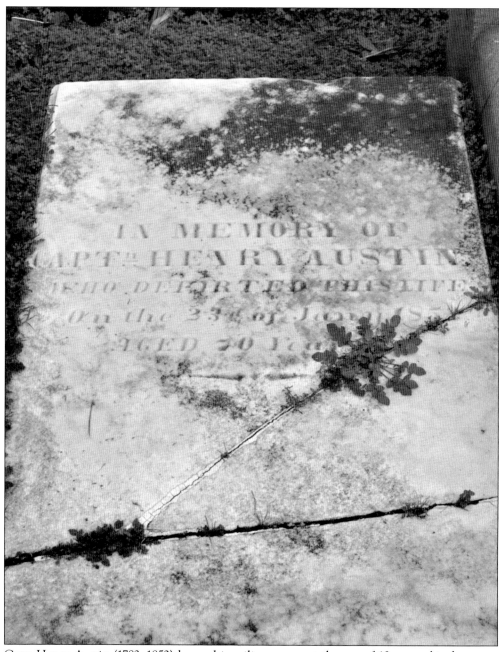

Capt. Henry Austin (1782–1852) began his sailing career at the age of 12 as a cabin boy on a sealing and trading voyage to China. When Austin returned home, he found that his father had died, and he was now partly responsible for the support of his family. Austin worked in various businesses in Connecticut until he received a letter from his cousin Stephen F. Austin in 1824 encouraging him to move to Texas. After an unsuccessful venture in Mexico, he purchased the steamboat *Ariel* and became the first captain of such a vessel on the Rio Grande in 1829. Austin became frustrated with the navigational hazards of the area and abandoned the ship in the San Jacinto River. He arrived at his cousin's colony in 1830, where he applied for a land grant. Austin selected a point on the Brazos for his plantation, which he named Bolivar. (TE/KSM.)

Two

BUSINESSMEN
AND PHILANTHROPISTS

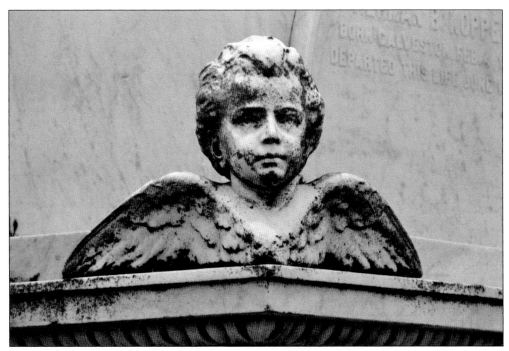

Pictured here is one of four cherub heads sitting at the corners of the Moritz Kopperl monument. (HEB/KSM.)

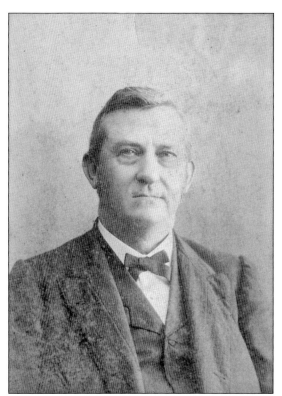

George Sealy Sr. (1835–1901) arrived from Pennsylvania in 1857 and went to work for Ball, Hutchings and Company where he eventually became a partner. President of the Gulf, Colorado & Santa Fe Railway after the Civil War, he was key in extending the rail lines into Indian Territory, Oklahoma. He was widely known for his generosity and as one of the organizers of the Galveston Children's Home. (TE/GTHC.)

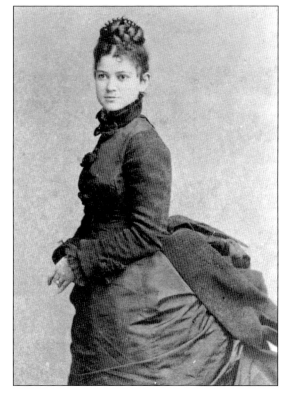

Magnolia Willis Sealy (1854–1933), wife of prominent businessman George Sealy, was an oleander enthusiast who supervised plantings of the exotic flower across the island, helping establish Galveston's reputation as the Oleander City. After the 1900 hurricane, she opened her lavish home known as Open Gates to shelter nearly 400 storm victims. Sealy also helped to found the Women's Health Protective Association, later known as the Galveston Civic League. (TE/GTHC.)

Richard Short Willis (1821–1892) was one of the wealthiest merchants in Galveston. Along with his brother Peter, he operated a dry-goods store that expanded into cotton factoring and importing goods. Willis also acted as president of Galveston National Bank and Texas Guarantee and Trust Company, director of the Gulf, Colorado & Santa Fe Railroad, director of the Southern Cotton Press and Manufacturing Company, and chairman of the Deep Water Committee. (TE/GTHC.)

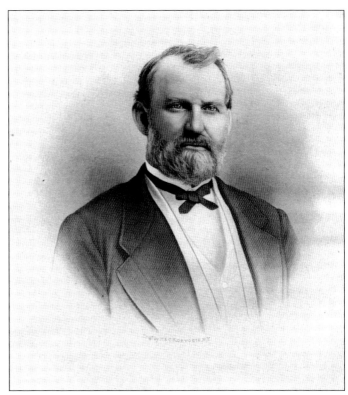

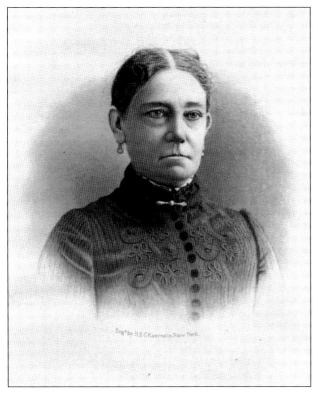

Narcissa Worsham Willis (1828–1899), the wife of Richard Short Willis, began building the mansion of her dreams within a year of her husband's death. She contracted architect William Tyndall to design a grand showcase on Broadway, now known as Moody Mansion. Her new home was completed four years before her death. Willis's daughter Olive sold the manor to W.L. Moody for $20,000 just days after the 1900 storm. (TE/GTHC.)

Caroline Womack Willis (1828–1863) moved from Alabama to Texas with her parents in 1841. She married Peter Willis in 1844 and settled in Montgomery County, where the town of Magnolia was named after her daughter. After moving to Galveston, she became the matron of one of the most affluent families on the island. (TE/GTHC.)

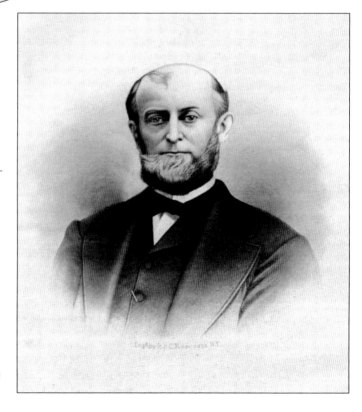

Peter James Willis Sr. (1815–1873), born in Maryland, moved to Galveston and engaged in business with his brother Richard. Their firm P.J. Willis and Brother became the largest export firm west of the Mississippi, with offices in London, Paris, and New York. After his wife's death, he and his sons moved to Matamoros, Mexico, to ship cotton and goods to England in exchange for cash to aid the Confederacy. (TE/GTHC.)

William Fowle Ladd (1846–1911) was a native of New England who engaged in business in New York for several years before relocating to Galveston. His cotton brokerage Ladd and Company was located on the Strand. He served as president of the Galveston Cotton Exchange and Board of Trade, president of the chamber of commerce, and was on the board of directors of Gulf City Cotton Press and Manufacturing Company. (TE/GTHC.)

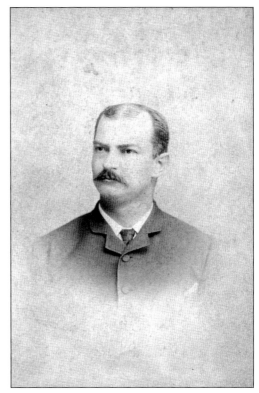

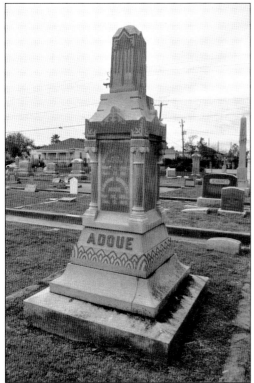

Bertrand Adoue (1841–1911) learned the mercantile trade after serving in the Civil War. He cofounded a grocery business and banking enterprise that expanded to handle exclusive rights of all cotton products in the state. Adoue was a principal officer of A.H. Belo and Company, Galveston Brewing Company, Galveston Hotel Company, and Surf Bathing Company. He also held the official positions of Galveston's consul for France, Norway, and Sweden. (EV/KSM.)

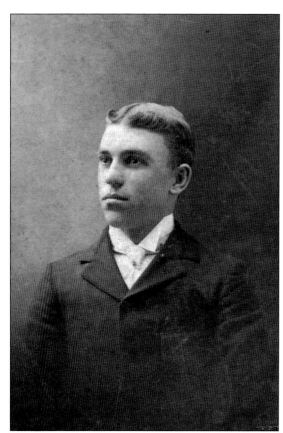

Herman F. Kleinecke (1843–1898) was one of 12 children born to German immigrants. The son of a butcher, he apprenticed in the family trade under an older brother. Kleinecke enlisted in the Confederate army in 1862 and fought in the Battle of Galveston. He later ran a butcher stall in the central market for 22 years. Kleinecke lost his wife and three of his eight children in the 1900 storm. (OC/KSM.)

Capt. Abraham Parker Lufkin (1816–1887), born in Bucksport, Maine, went to sea as a cabin boy and followed a seafaring life until he moved to Galveston in 1845. In 1847, he built Lufkin's Wharf at the foot of Twenty-fifth Street. With partner Charles Emerson, Lufkin built the port's first steamboat and later the first steam cotton press in Galveston. The town of Lufkin, Texas, was named in his honor. (TE/KSM.)

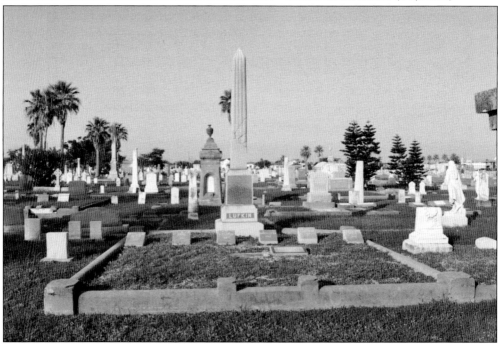

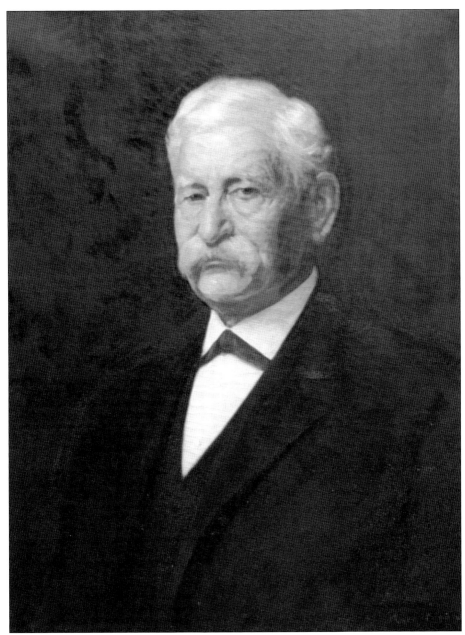

Morris Lasker (1840–1916) immigrated to the United States from Prussia in 1856, settling in Texas in 1860. He fought in a number of Indian campaigns and served with the Confederacy during the Civil War. After the war, he owned four mills, including Texas Star Flour and Rice Mills, was president of three Galveston banks, one-time president of the Galveston Cotton Exchange, and a successful real estate and livestock dealer and merchant. He was elected to the Texas state senate in 1895. As one of Galveston's most notable philanthropists, Lasker provided funds to the Adoue Seaman's Bethel, the Osterman Widow and Orphans Fund, the Galveston Orphans' Home, the Letitia Rosenberg Home for Women, and the Lasker Home for Homeless Children. He was also an active member of the Temple B'Nai Israel congregation and served on the Galveston Board of School Trustees. (HEB/KSM.)

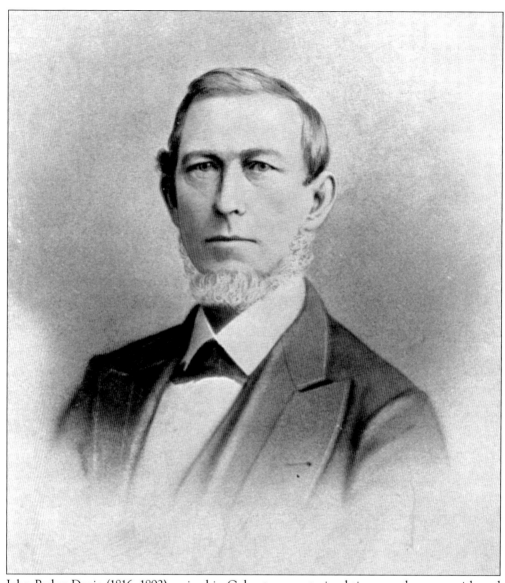

John Parker Davie (1816–1892) arrived in Galveston as a trained tinner and coppersmith and opened a tin shop on the corner of Mechanic and Twenty-second Streets. He soon built a brick building, the second structure of its kind on the island, with J.P. Davie Wholesale Hardware on the first and fourth floors, and the Cosmopolitan Hotel (later renamed the Washington Hotel) on the remaining floors. In addition to the mercantile, he founded a brickyard in Houston and owned stock in local enterprises such as the Galveston Wharf Company. He used his mechanical and metalwork background to design and receive a patent for a self-regulating windmill. Twice a member of the city council, Davie was one-time acting mayor of Galveston. His burial vault, constructed in 1878, was the largest in the cemetery at the time at 20 feet high and was capable of holding 24 bodies. His will generously provided for extended family members, two orphanages, a fund for needy citizens, a parsonage for a local Presbyterian church, and a house and allowance for a former slave and her daughter. (OC/GTHC.)

Leon Blum (1836–1906), an Alsatian immigrant, moved the mercantile he began with his brother in Richmond, Texas, to Galveston in 1859. Within 10 years, the firm was the city's leading importer and wholesaler of dry goods, serving the Southwest, Indian Territory, and Mexico, with offices in New York, Boston, and Paris. The headquarters building of Blum and Company is now home to the elegant Tremont House hotel. (HEB/GTHC.)

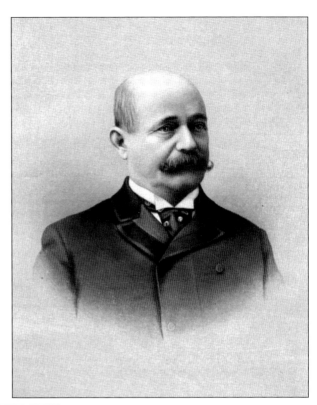

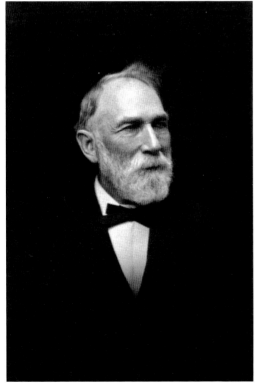

Waters Smith Davis (1829–1914), a Confederate veteran, co-owned one of the most lucrative mercantiles in the state. His business success provided the opportunity to serve the community as the president of the Galveston Wharf Company board and contributor to the building of the Gulf, Colorado & Santa Fe Railroad. An avid amateur Egyptologist, Davis donated exotic collections from his travels to the Rosenberg Library. (TE/GTHC.)

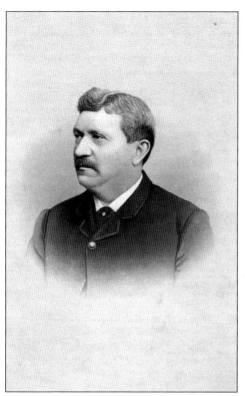

Harris Kempner (1837–1894) immigrated to New York from Russian Poland in 1854 and moved to Texas in 1858. He served in the Confederate Texas cavalry before moving to Galveston in 1870, where he co-established one of the largest grocery stores in Texas. Kempner was a stockholder and director of 10 national banks in Texas and a charter member and director of the Gulf, Colorado & Santa Fe Railway. (HEB/GTHC.)

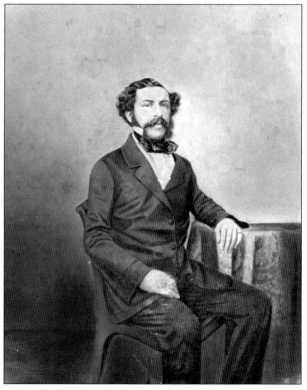

Moritz Kopperl (1826–1883) was born in Moravia and immigrated to Mississippi to live with his uncle. He relocated to Galveston in 1857 and opened a dry-goods store, which burned during the Civil War blockades. Kopperl next went into the import business, helping to make Galveston one of the world's largest coffee-importing ports. He was elected to the Texas legislature in 1876. Kopperl, Texas, is named in his honor. (HEB/GTHC.)

Allen Lewis (1819–1870) was among 36 passengers lost at sea aboard the steamship *Varuna* during a storm off the coast of Florida. Co-owner of Allen Lewis and Company Cotton and Wool Factors, he was a leader in the local business and Methodist communities. Lewis served on the board of directors for Galveston Wharf Company and was a director with the Southern Cotton Press and Manufacturing Company. (OC/KSM.)

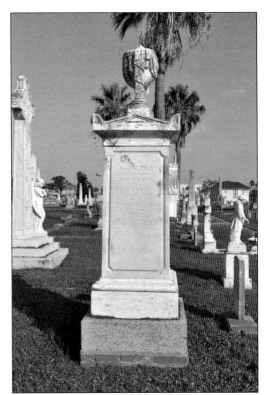

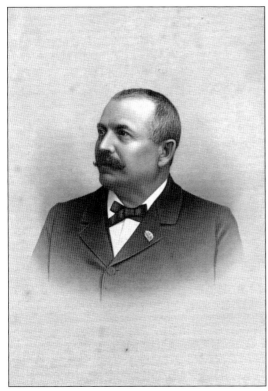

Marx Marx (1836–1909) emigrated from Germany and became friends with Brigham Young during his travels. After settling in Galveston, he became a merchant dealing at various times in groceries, boots, shoes, and hats. He was the president of Acme, Red River & Northern Railway Company and was appointed to the board of regents of the University of Texas. (HEB/GTHC.)

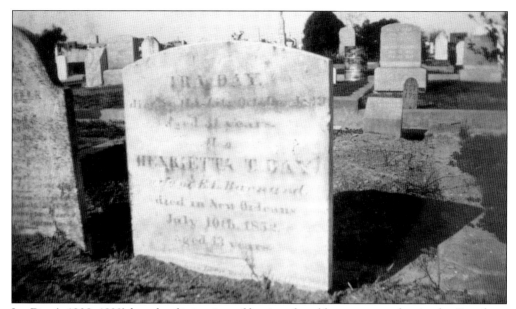

Ira Day (c.1808–1839) has the distinction of having the oldest grave marker in the Broadway cemeteries. In March 1839, during the incorporation of Galveston as a city, he volunteered for the job of city gauger in charge of inspecting the casks and bulk goods coming into the port to determine any duty to be paid. He died the following October at 31 years of age. (OC/GTHC.)

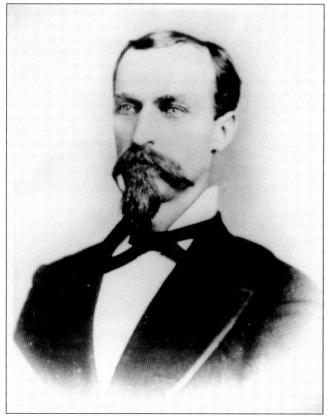

Bernard Moore Temple (1843–1901) was a former Confederate soldier who became a noted civil engineer. After moving to Galveston in 1875, he became chief engineer for the Gulf, Colorado & Santa Fe. He was later Southern Pacific Railway Company's resident engineer for building the Pecos River High Bridge in Langtry, Texas, the highest railroad bridge at the time. Temple also served as Galveston's city engineer and superintendent of the waterworks. Temple, Texas, was named for him. (OC/GTHC.)

Sally Trueheart Williams (1871–1951), daughter of Henry Martyn Trueheart, was fascinated with history. In addition to being a member of the Daughters of the Confederacy, Daughters of the American Revolution, and Colonial Dames, she founded the history committee of the Texas Federation of Women's Clubs. Williams was an advocate for education and developed a copyrighted trivia card game called *Texas Heroes: An Instructive Game.* (EV/GTHC.)

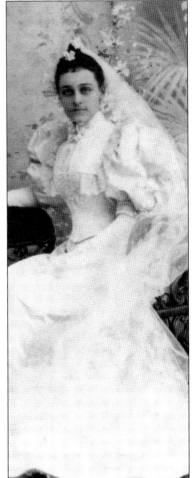

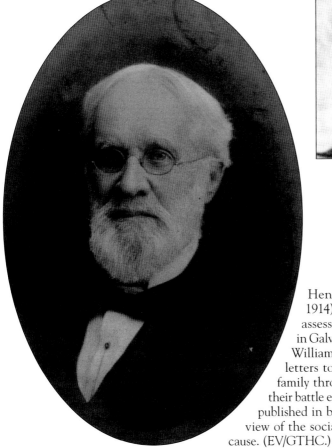

Henry Martyn Trueheart (1832–1914) was a Galveston County tax assessor and real estate businessman in Galveston. He and his brother Charles William (1837–1914), a physician, wrote letters to each other, their friends, and family throughout the Civil War detailing their battle experiences. The letters have been published in book form and give an insightful view of the social motivations of the Southern cause. (EV/GTHC.)

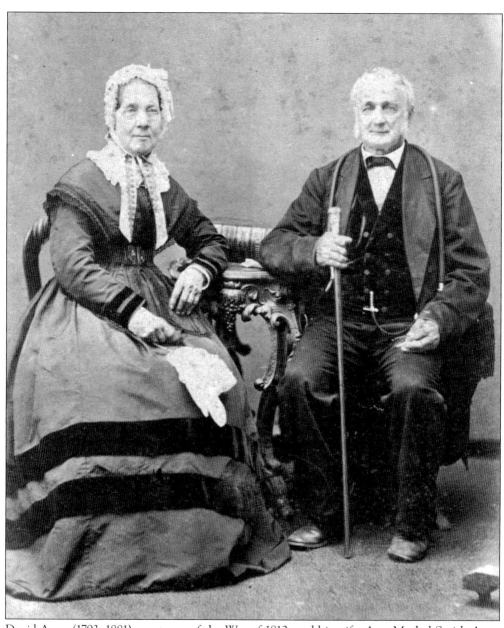

David Ayers (1793–1881), a veteran of the War of 1812, and his wife, Ann Moshel Smith Ayers (1799–1876), came from New York with their six children, carrying what is believed to be the first boxes of Bibles brought to Texas on behalf of the American Bible Society. The family first settled in San Patricio, then moved to Washington County, where Ayers became friends with leaders of the Texas revolution. No longer able to serve in the military due to his deafness, Ayers was assigned to lead many families to safety during the Runaway Scrape. He was one of the founders of Rutersville College in Fayette County in 1840, the first institution of higher learning in the state. In 1847, he moved his family to Galveston, where he began a successful mercantile business and continued to be a prominent civic and religious leader. Ayers was the publisher of the *Texas Christian Advocate* and a major contributor to the building fund of St. James Methodist Church in Galveston. (OC/GTHC.)

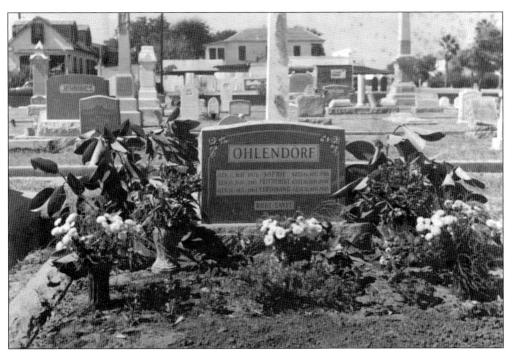

Ferdinand H. Ohlendorf (1862–1953) emigrated from Germany as a young man and began a door-to-door magazine and newspaper service. He eventually opened his own store specializing in English and German books and souvenir postcards, which he published himself. An active member of the community, Ohlendorf was a mason, member of the Concordia Singing Society, and president of the Galveston Suburban Improvement Company. His epitaph, *"Ruhe Sanft,"* translates to "Rest Gently." (EV/GTHC.)

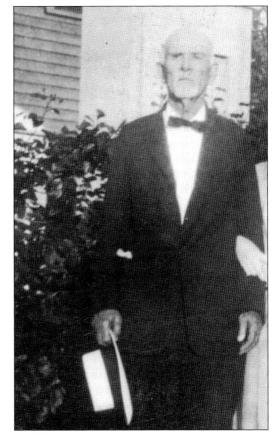

John Adriance (1844–1923) worked in his uncle's commission house in Columbia, Texas, after serving in the Confederate army. He moved to Galveston in 1866 and worked various jobs in exchange for room and board. Adriance married into the prominent Trueheart family and joined Henry M. Trueheart's business, one of the oldest and largest real-estate firms in the state. The name changed to Adriance and Sons after Trueheart's retirement. (EV/GTHC.)

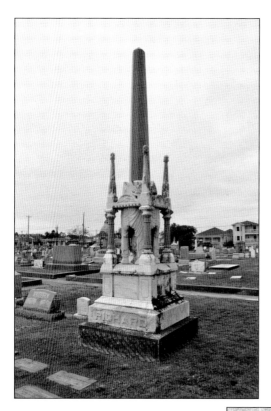

Athen Victor Pichard (1847–1883), a native Galvestonian, was sent to Europe at age 16 to complete his education, but he ran away from school to return home and join the Confederate army. After the war, he went to commercial college in New Orleans and returned to Galveston to begin a lucrative career in the hide and wool business. Pichard was a member of the city council for two years. (EV/KSM.)

Judge Edward Tailer Austin (1822–1888), a relative of Stephen F. Austin, was raised on a plantation in Brazoria County. In the 1850s, he followed the lure of gold to California, but illness kept him from achieving success there. After recuperating in Hawaii, where he worked as an overseer on a plantation, he returned to Galveston and made his livelihood as a county judge, city alderman, and county attorney. (OC/GTHC.)

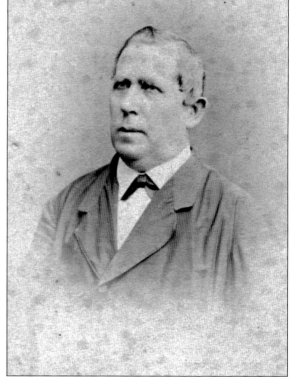

John Charles League (1850–1916), a Galveston financier, purchased land along the Galveston, Houston & Henderson Railroad in 1890 and platted the township of League City, originally called Clear Creek. He donated land for the first park, school, and church in the town. In 1907, League provided two railroad flatcars of live-oak trees for residents to plant on their property. Many of those trees still line the streets today. (TE/GTHC.)

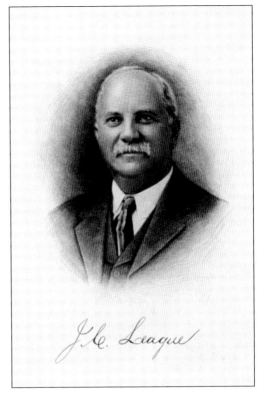

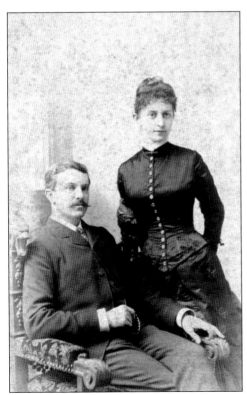

Gustav Reymershoffer (1847–1903) sailed from Austria to Galveston with his parents in 1854 and settled in Austin County, Texas. In 1866, he and his brother John moved to Galveston and founded the importing business J. Reymershoffer's Sons. A dozen years later, after their father's death, the brothers established the Texas Star Flour Mills and engaged in trade with Europe and Latin America. In 1884, he married Eugenie T. Rubelmann (1862–1961). (OC/GTHC.)

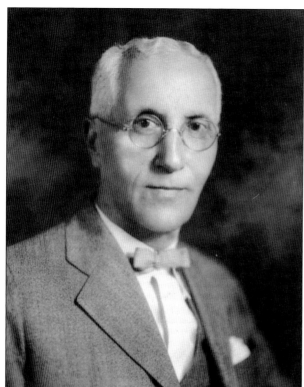

Jules Block (1862–1936), an immigrant from France, was the proprietor of the successful scrap iron, metal, and junk firm J. Block and Company, treasurer of Consolidated Arizona Mines, one-time director of the US National Bank of Galveston, and held interests in Singer Iron and Steel and other large corporations. Block was chairman of the Beachfront Development Committee that helped Galveston to recover financially after World War I. (HEB/GTHC.)

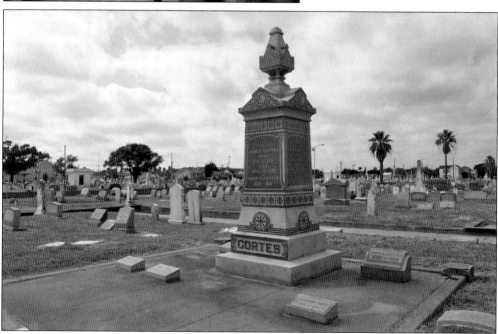

Henry W. Cortes (1831–1899) established the Texas Bottling Works in 1860 and opened a branch in Brenham in 1884. The business manufactured syrup, soda, sarsaparilla, ginger ale, and mineral water as well as bottled beer, porters, and ales. The German-born entrepreneur was also a real-estate investor and on the building committee of the German Presbyterian Church. (OC/KSM.)

John Henry Hutchings (1822–1906) and his wife, Minnie Knox Hutchings (1838–1915), married in 1856 and had eight children, two of which were named after their parents, and another two were named after Hutchings' business partners. Hutchings moved to Galveston in 1845, and by 1854 had formed a partnership with John Sealy and George Ball named Ball, Hutchings and Company, later known as the Hutchings-Sealy Bank. He played a crucial role in improving the local harbor. During the Civil War, the firm moved to Houston, where Hutchings was active in importing arms and other supplies for the military. He served as a commissioner of the Confederate State Court and later became president of the Galveston Wharf Company. For 50 years, Minnie Hutchings played a prominent role in the social life of the city. (Both, TE/GTHC.)

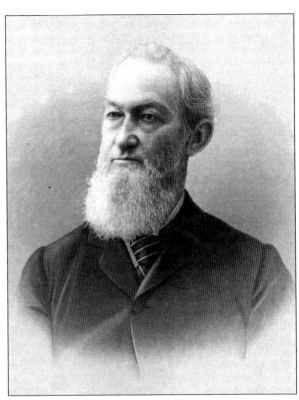

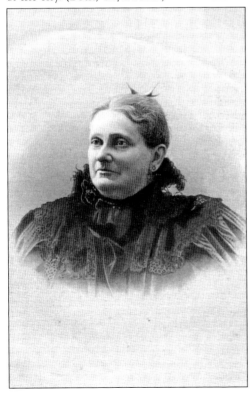

Michael Seeligson (1797–1867), born in Holland, came to Galveston in 1838. His wife, Adelaide, and their family joined him the following year. Seeligson played a critical role in the movement to have the Republic of Texas annexed to the United States. He served as alderman of the city in 1840 and 1848 and was the first Jewish mayor elected in Galveston. (OC/GTHC.)

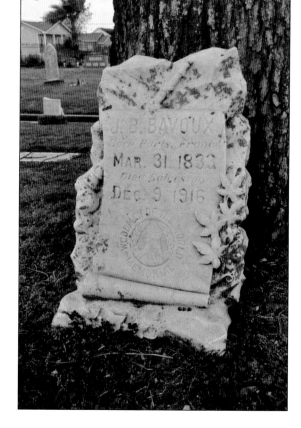

In 1858, Jean Baptiste Bavoux (1833–1916), born in Paris, France, married Marie Eveline Baudenon in Galveston. Four years later, he enlisted in Menard's Company of the Confederate cavalry. Bavoux lived in Galveston for 75 years and worked as a barber in his own shop. He was a charter member of the Societe Francaise, and his classic treestone marker indicates membership in Woodmen of the World. (OC/KSM.)

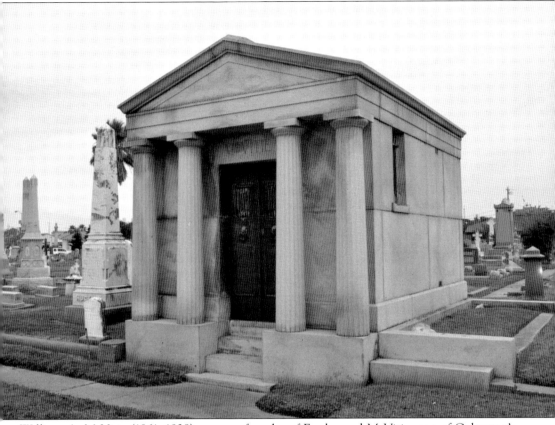

William A. McVitie (1861–1938) was a cofounder of Fowler and McVitie, one of Galveston's oldest steamship companies. A native of Liverpool, England, he was vice president of both the Galveston Cotton Exchange and Galveston Maritime Association and served as chairman of the Galveston Relief Committee after the 1900 storm. McVitie was one of the earliest golfers on the island, and was elected captain of the Galveston Country Club, the state's first chartered club, in 1904. He and his wife, Jessie Barbour McVitie (1863–1942), a native Texan, were active in numerous charitable pursuits and generous donors to Trinity Episcopal Church. Their only child, Ethel Mabel McVitie (1892–1920), also a philanthropist, died in their home at the age of 27. The cloister of Trinity's parish house is dedicated in her honor. After McVitie's retirement, he and his wife moved to Rye, New York, but maintained their home in Galveston for their frequent visits. Upon her death, his widow willed their elaborate residence to the church. The three members of the McVitie family rest together in the McVitie mausoleum. (TE/KSM.)

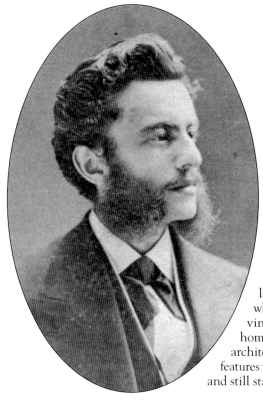

Jacob Sonnenthiel (1841–1908), pictured here with his wife, Sallie Levy Sonnenthiel (1856–1938), was a German immigrant who served the Confederacy in Company C of the 12th Alabama Infantry during the Civil War. His unit fought at both Gettysburg and Antietam. After moving to Galveston, he operated a wholesale dry-goods store on the Strand and later owned Acme Vinegar and Pickle Works, which manufactured different types of ciders and vinegars. The Sonnenthiels built an impressive home, thought to have been designed by famous architect Nicholas Clayton, in 1887. It incorporates features with Eastlake, Gothic, and Italianate influences and still stands on Sealy Avenue. (Both, HEB/GTHC.)

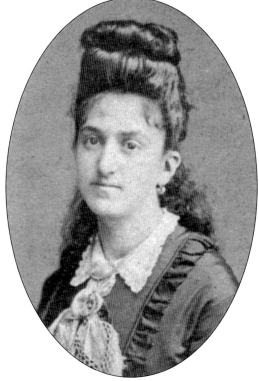

Johann "John" Focke (1836–1907) emigrated from Germany and settled in Galveston shortly after the Civil War. In 1866, he married Georges Anna Dorothea Marckmann in the American Embassy in Berlin, after falling in love aboard ship during a European vacation. Cofounder of Focke, Wilkens and Lange, a wholesale grocery and cotton firm, Focke was one of the city's most prominent and respected businessmen of his time. (TE/Smalling.)

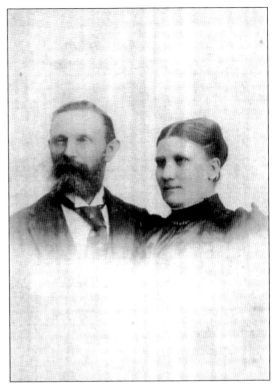

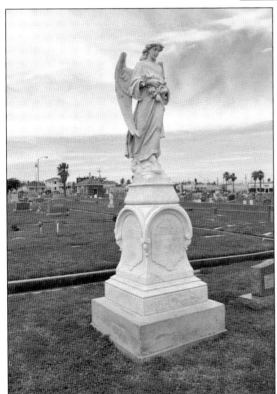

Isidore S. LeClere (1815–1885) learned the trade of a saddler at age 15. In 1837, representatives of his relative Col. Michel Menard led him from Missouri to the Republic of Texas. LeClere served as a ranger in an expedition against the Comanche Indians and helped to defend the Republic against Mexico. He later became the Galveston Wharf Company's first secretary and general manager, a position he retained for 25 years. (CATH/KSM.)

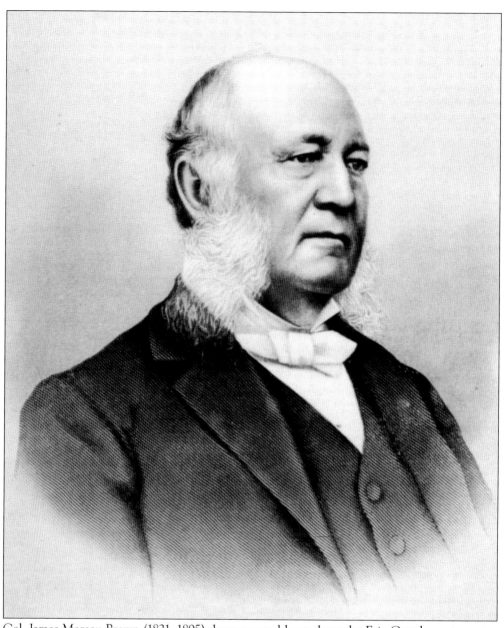

Col. James Moreau Brown (1821–1895) drove a canal boat along the Erie Canal as a teenager, working with Charley Mallory, later of Mallory Steamship Lines. After an apprenticeship as a brick mason and plasterer, Brown moved to Galveston in 1843, where he worked on the first brick jailhouse on the island, St. Mary's Cathedral, and the old market. When his partner in Brown and Kirkland Hardware died in 1859, he closed the business and became president of the Galveston, Houston & Henderson Railroad. He built what is reputed to be the state's first brick house, Ashton Villa, the same year. After the Civil War, Brown opened another hardware business that became one of the largest enterprises of its kind in the South. He soon became one of the wealthiest men in Texas. He served as director and president of both the First National Bank of Galveston and the Galveston Wharf Company. Brown was a member of the Knights Templar and the Odd Fellows. (TE/GTHC.)

Stephen Kirkland (1814–1859) came to Texas from Oneida County, New York, to assuage his asthma at the advice of his doctor. After pursuing a variety of businesses, Kirkland formed a lucrative hardware business with James Brown in 1850. A city alderman, he helped organize one of the first fire departments on the island and aided the establishment of the local masonic and Odd Fellows chapters. (OC/KSM.)

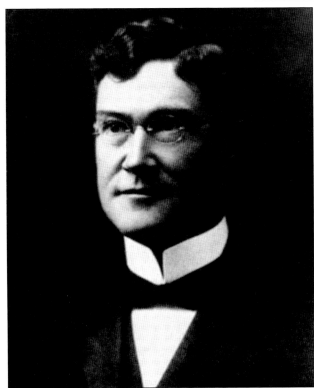

James Jefferson Davis (1867–1922) was one of the most prominent masons in the state, having served as grand master of the Grand Lodge of Texas and grand commander of the Texas Commandry. Born in New Orleans, Davis was brought to the island as an infant. A respected businessman, he was vice president and manager of the Galveston Wharf Company and director of the Houston Branch of the Dallas Federal Reserve Bank. (TE/KSM.)

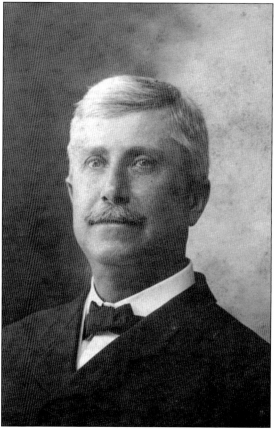

Charles William Gill Sr. (1858–1924) was a 32nd-degree mason who made his fortune dealing in Galveston real estate and rental properties. In 1909, he purchased the famous Murdoch's Bathhouse in partnership with Albert Shafer and J.J. Davis. He was also co-owner of the Gill-League Building at the corner of Twenty-first and Market Streets, where Douglas "Wrong Way" Corrigan was born. (TE/KSM.)

Maurice Sidney Ujffy (1857–1930) came to Galveston in 1876 and gained employment with a wholesale grocery business, eventually becoming an independent broker. He served as a member of the county commissioner's court from 1904 to 1906, secretary and treasurer of the McAlester and Galveston Coal Mining Company, and a leading proponent for building a causeway to the mainland. Ujffy donated a substantial sum of money for planting trees along Broadway. (EV/GTHC.)

Capt. Worthy Boyd (1859–1937) came to Galveston from New Orleans with his parents in 1872. After graduating from Texas A&M University, he began working for local cotton firms as a clerk. In 1884, Boyd joined the Sealy Rifles in the Texas Volunteer Guard. As part owner of Boyd and Marrast Cotton Weighers, he became a state weigher for the port of Galveston. He later founded a marine services company. (OC/GTHC.)

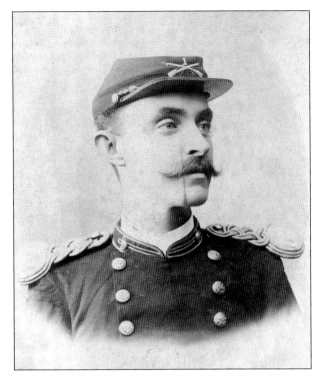

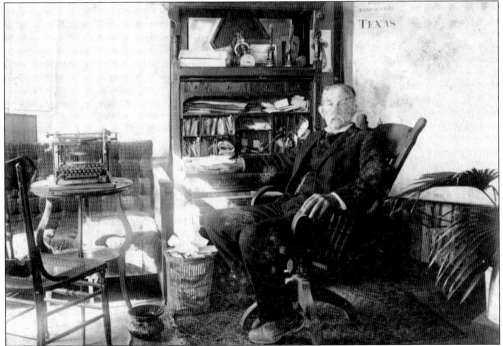

John Caplen (1849–1915) was born and raised in Galveston and was an active proponent for modernizing the area. A real-estate dealer for 30 years, he conducted the original survey of the Bolivar area in 1909. He eventually settled in Alta Loma, building an impressive estate named the Sycamores, which became a regular center of social gatherings. (OC/GTHC.)

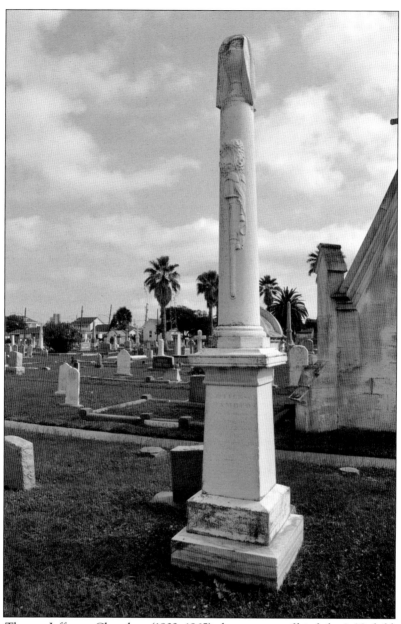

Maj. Gen. Thomas Jefferson Chambers (1802–1865), the youngest of his father's 20 children, began his career as a lawyer in Kentucky and Alabama. Early in 1826, he moved to Mexico where, after mastering the language, he was appointed surveyor general of the State of Coahuila and Texas and became a Mexican citizen. His support of the Mexican government during the Texas Revolution caused many to consider him a traitor, and he was hanged in effigy in Brazoria County. After the Texans' victory at Gonzales, Chambers took steps to support the rebels. Using his land as credit, he raised troops and ammunition for Texas in exchange for the title of major general. He retired to his home near Anahuac and changed the town's name to Chambersia. While away on a business trip, Chambers lost part of his land in what had become a bitter legal dispute. Numerous suits over controversial land claims ensued, including one involving the capitol grounds. An unidentified assassin shot Chambers through the window of his Anahuac home. (TE/KSM.)

Three

POLITICIANS AND COMMUNITY LEADERS

Although an anchor on a grave marker can denote hope, in a port city such as Galveston it is more likely to indicate the occupation of the deceased. David McCluskey's stone in Evergreen Cemetery features both an anchor and binoculars, which he would have used in his job as a ship pilot and port warden. (EV/KSM.)

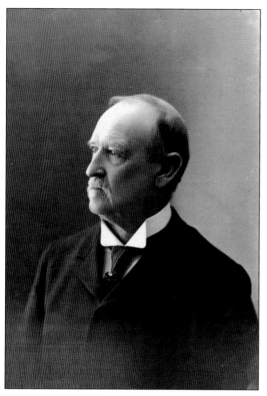

Maj. Augustus John Walker (1834–1904), a native of North Carolina, was a Confederate veteran of Vicksburg and other battles of the Civil War. He came to Texas in 1854, where he soon became mayor of Port Lavaca. Relocating to Galveston in 1866, he worked in the cotton factors and brokerage businesses for the remainder of his life. He was a director and advisor of the Galveston City Railway Company, president of the Southern Cotton Compress and Manufacturing Company, director of the Texas Guarantee and Trust Company, and a friend and advisor to Galveston's most influential citizens. Walker dedicated the last 10 years of his life to carrying out bequeaths from Henry Rosenberg's will, including the Rosenberg Library and Texas Heroes Monument. A bust of Walker, who died in his apartment at the Tremont Hotel, is at the Rosenberg Library. (Both, EV/GTHC.)

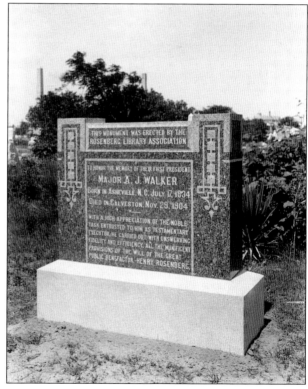

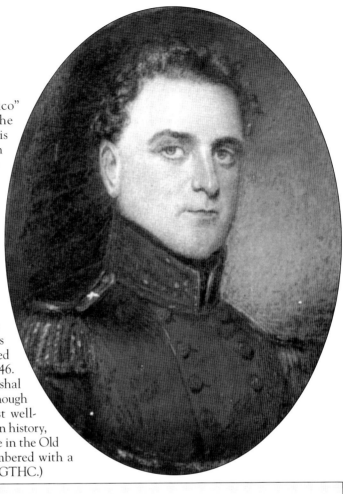

Maj. John Melville "Tampico" Allen (1798–1847) was the first mayor of Galveston. His adventurous spirit led him to serve in the US Navy to fight in the Greek revolution against Turkey, befriend the poet Lord Byron, and become a privateer in the Gulf. Appointed as acting major at the Battle of San Jacinto, he was also an early mason. In 1840, when Samuel May Williams attempted to end his mayoral term early, Allen moved the city archives to his home and posted two cannons for protection. He was reelected every year afterward until 1846. He was appointed a US marshal after Texas's annexation. Although Allen's was one of the most well-attended funerals in Galveston history, he rests in an unmarked grave in the Old City Cemetery. He is remembered with a historical marker. (Both, TE/GTHC.)

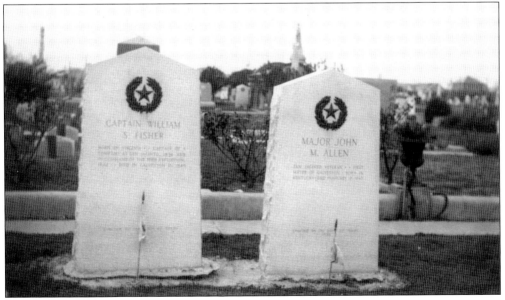

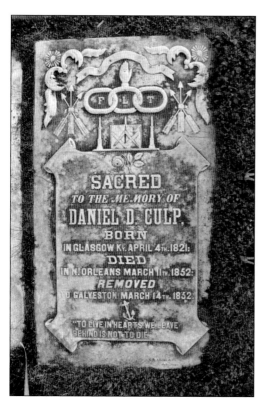

Daniel D. Culp (1821–1852) was Sam Houston's private secretary. He also served as the official notary public for Harris County from 1843 until 1845 and postmaster of Cherokee County from 1850 to 1851. When General Houston received word of Culp's death in New Orleans, he arranged for the remains to be accompanied by masonic and Odd Fellows representatives aboard a steamer back to Galveston for burial, at his expense. (TE/KSM.)

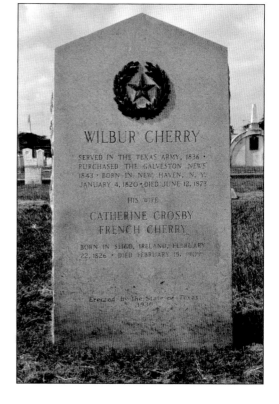

Wilbur Alexander Cherry (1820–1873) ran away from home at age 15, coming to Texas in 1835. He participated in the Texas Revolution and afterward joined the Army of the Republic of Texas. After working as a printer in Austin, he moved to Galveston and helped establish the newspaper now known as the *Galveston Daily News*. (OC/KSM.)

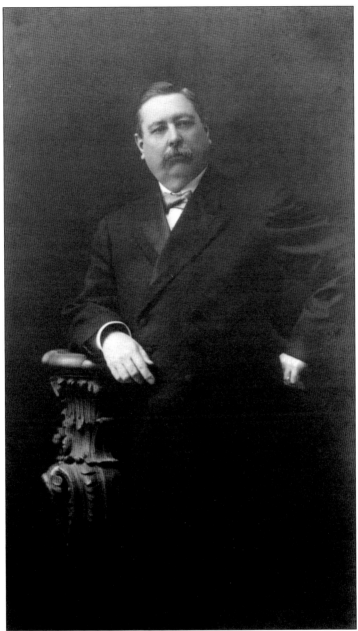

Dr. Ashley Wilson Fly (1855–1919) was a professor of anatomy at the Texas Medical College, a visiting surgeon at St. Mary's Hospital, president of the Galveston Board of Health, mayor of the city from 1893 to 1899, and on the University of Texas board of regents from 1909 to 1911. As mayor, he was known as a headstrong rogue who wore six guns and frequently threatened to use them. During a violent wharf labor strike he drew a line across the dock and asked anyone in favor of a strike to step across, adding that he would shoot the first person who did. Taking office during an unethical chapter in the city's political history, he helped to establish measures to clean up financial corruption. When local officials would not appropriate funds to examine the city's books, Fly paid for it out of his own pocket. His third term came to an abrupt halt when Galveston came under martial law after the 1900 storm. (TE/GTHC.)

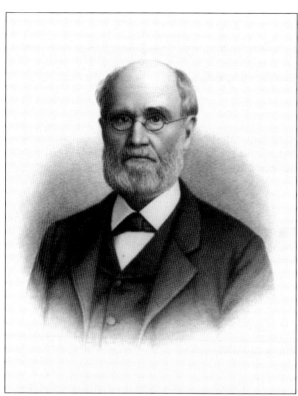

Judge John Woods Harris Sr. (1810–1887), born in Virginia, was elected to the Texas House of Representatives in 1839, where he proposed abolishing Mexican laws. He represented Matagorda, Galveston, and Brazoria Counties and later became the new state's first attorney general before returning to his successful law practice in Galveston. (TE/GTHC.)

Col. James Love (1795–1874), a veteran of the War of 1812, was a member of the Kentucky House of Representatives and the US Congress. After arriving in Texas in 1837, he was a delegate to the 1845 Annexation Convention. Because Love served the Confederacy as a member of Terry's Texas Rangers, he was removed from his position as the first judge of the Criminal Court of Galveston and Harris Counties during postwar occupation. (TE/KSM.)

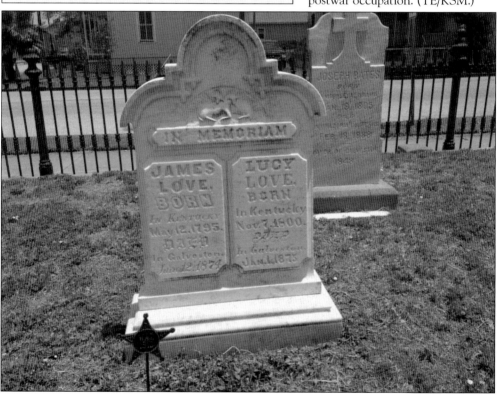

Michel Branamour Menard (1805–1856) was a Canadian fur trader considered to be the founder of the city of Galveston. Leaving Quebec at age 14, Menard became a trader for John Jacob Astor and then a resident trader with a band of Shawnee Indians, who he eventually followed to Texas in the 1830s. There he began land speculating and obtained 4,600 acres at the east end of Galveston Island with the help of Battle of San Jacinto–veteran Juan Seguin. Menard formed the Galveston City Company with Samuel May Williams, and Galveston was incorporated the following year. A signer of the Texas Declaration of Independence in 1836, he also served in the Texas House of Representatives in the Fifth Congress of the Republic. Menard lost three of his four wives to tragedy and was survived by his fourth wife and a son. (Both, CATH/GTHC.)

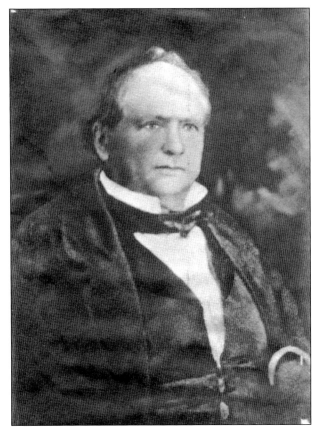

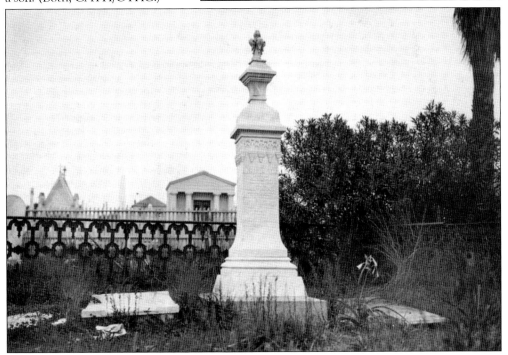

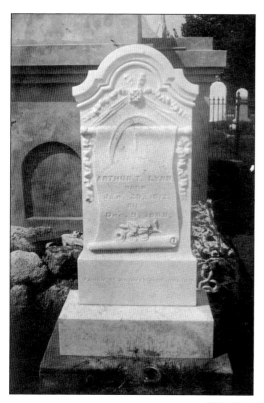

Arthur Thomas Lynn (1812–1888), who was described as remarkably handsome by his contemporaries, came to Galveston from England while Texas was still a republic and was appointed consul general for Great Britain in 1850. He was a successful merchant, respected mason, and brother of British author Eliza Lynn Linton. Lynn became a naturalized citizen in 1854. The inscription on his gravestone reads, "A noble of nature's own making." (TE/GTHC.)

Joseph Osterman Dyer (1854–1912) moved to Galveston in 1876 and began his medical practice in 1881. He is most remembered as a historian however, having gathered stories from some of the pioneers of Galveston, including surviving members of pirate Jean Lafitte's commune. He wrote popular columns for the local newspaper about coastal Indians and the early days of settling the island. (OC/KSM.)

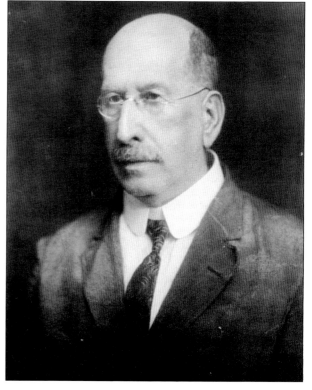

Albert Nelson Mills (1822–1898), a graduate of the College of William and Mary, joined the Mount Vernon Guards in 1842 and served in the Mexican War. After moving to Texas, he represented Gonzales in the Texas legislature. Mills voted to secede from the Union on behalf of Gonzales County and was appointed provost marshal for three counties. He joined the Confederate army and eventually obtained the rank of major. He practiced law until he became deaf in 1891 and was cared for until his death by his former slave Julia Wood. She was generously compensated for her devotion in his will. (Right, GTHC; below, TE/KSM.)

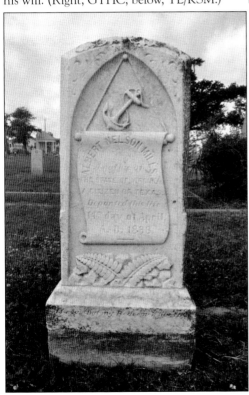

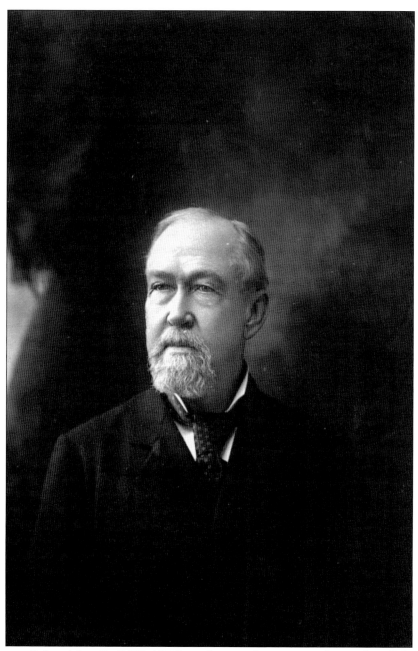

Col. Marcus Fulton Mott Sr. (1837–1906) was born in Louisiana and moved to Galveston in 1845. During the Civil War, he served as a lieutenant of artillery, an aide to General Scurry at the Battle of Galveston, and a clerk of the Confederate States Court. He was later elected to several offices, including city attorney, city judge, the board of health, judge advocate general of the Texas Volunteer Guard, and head of the department of military justice. Twice elected grand master of the Grand Masonic Lodge of Texas, he was also trustee and president of the board of directors of the Rosenberg Library and an officer of the Galveston Widow's and Orphans Home. His prestigious law career eventually led to his election to the state senate of the 22nd legislature. Mott died from injuries sustained from falling from a streetcar. (TE/GTHC.)

Oscar Farish (1812–1884), a member of the Odd Fellows, participated in the Battle of San Jacinto, and in 1838 was elected clerk at the first Republic of Texas Congress. That same year, he was elected Galveston County clerk, an office he retained for 30 years. His term ended in 1868 when he refused to take the Ironclad Oath of allegiance to the United States after the Civil War. (OC/KSM.)

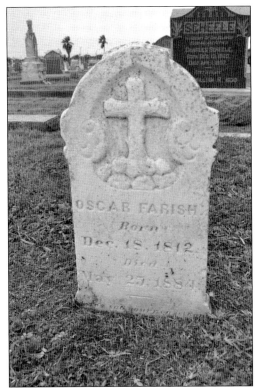

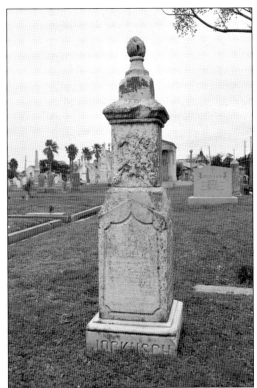

Loula Jockusch Blamont (1860–1897) was an elocution teacher and actress in local ladies' musicales who was known for her intellect and sweet nature. She was one of the founders of the Galveston Histrionic Society and was prominent in local literary circles. Loula married Adolph Wilhelm Blamont, a local teacher of German and French, and they both wrote and published dramatic works. She died after being married for only one year. (CATH/KSM.)

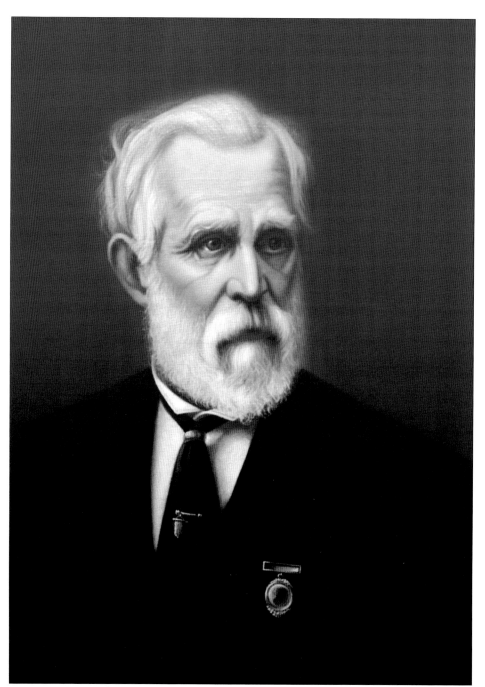

Dr. Greensville S. Dowell (1822–1881) settled in Texas in 1852 and served as a surgeon for the Confederacy in Galveston during the Civil War. After the war, Dowell and a group of physicians formed the Galveston Medical Society, which led him to a position as anatomy professor at Galveston Medical College, the first medical school in Texas. By 1867, he was dean of the college. He devised a cure for hernias by means of subcutaneous stitches. Dowell was also well known in the medical community for being the first to suggest the mosquito as a carrier of yellow fever, and for designing surgical instruments, including several types of forceps. (EV/UTMB.)

Dr. Harry Obadiah Knight (1880–1939) headed the Department of Anatomy at the University of Texas Medical Branch. He developed the concept of scientific exhibits as educational tools, playing a major role in helping UTMB build one of the finest museums of human anatomical specimens in the United States. Knight was the first chairman of the Committee on Scientific Exhibits (1926–1933) in the State Medical Association of Texas. (OC/GTHC.)

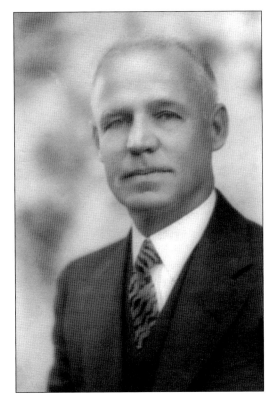

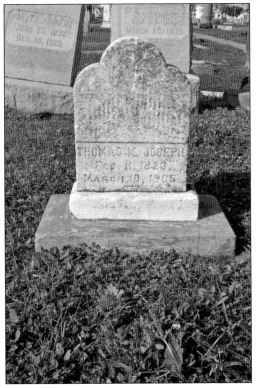

In 1841, Judge Thomas Miller Joseph (1823–1905) and his mother moved from Connecticut to Galveston, where he worked as a schoolteacher for two years while studying law. After being admitted to the bar in 1845, Joseph became a leader of the local Democratic Party, serving at various times as chief justice, county judge, state legislator, and senator. He was mayor of Galveston for five consecutive terms. (TE/KSM.)

Willard Richardson (1802–1875) moved to Texas to work as a surveyor in 1837. While writing for a local paper in Houston in 1844, he was offered the post of editor for the *Galveston News*. A friend of Mirabeau B. Lamar, he was a critic of Sam Houston and defender of slavery. Richardson, the city's mayor in 1853, is remembered for establishing the publication of the *Texas Almanac*. (OC/GTHC.)

James Edwin Thompson (1863–1927), a distinguished surgeon, anatomist, pathologist, and embryologist, was the first professor of surgery at the University of Texas Medical Branch. Born and educated in England, he became a member of the Royal College of Surgeons. After moving to Galveston in 1891, he spent 36 years devoted to his research and profession. Thompson was a founding member of the American College of Surgeons and a fellow of the American Surgical Association. (TE/GTHC.)

Samuel May Williams (1795–1858) traveled North and South America before arriving in Stephen F. Austin's colony in 1823, where he became a translator and clerk. In 1833, he founded a mercantile firm at the mouth of the Brazos River. Two years later, while traveling on business, he learned of fighting in Texas and gave approximately $100,000 of his firm's money to support the Texas Revolution. Known as the "Father of the Texas Navy," he helped build seven ships by 1838. His firm soon moved to Galveston, where, along with Michel B. Menard, he promoted development of the city. Williams organized Texas's first bank in 1848. His wife, Sarah Scott Williams (1807–1860), operated the family home during her husband's frequent absences, leaving only once with her children in 1836 during the Runaway Scrape to evade the approaching Mexican army. (Both, TE/GTHC.)

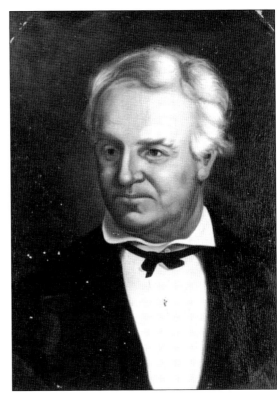

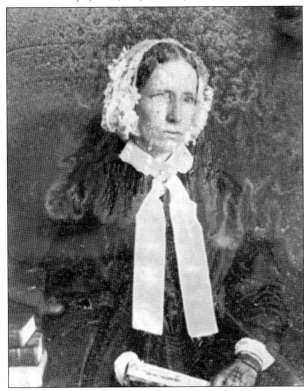

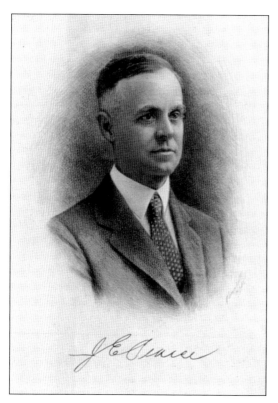

John "Jack" E. Pearce (1876–1935) came to Galveston from Kentucky as a telegraph operator, and then became employed handling steamer freight. By 1901, he began his own stevedoring company, branching out into other interests, including Murdoch's Bathhouse Company, Hotel Galvez Operating Company, and the old Grand Opera house. As mayor for five consecutive terms, he is remembered for defending prostitution as "an essential social balance" for the community. (TE/AC.)

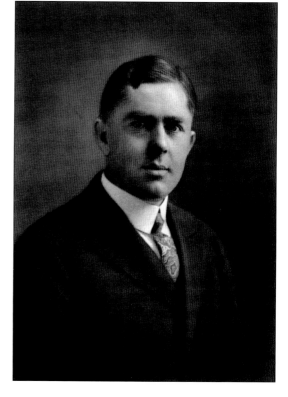

Baylis Earle Harriss (1883–1926) was a prominent cotton merchant who began working at the age of seven. As a youth, he worked as a store cash boy, telegraph messenger, and other odd jobs, eventually apprenticing in the cotton brokerage business. His partnership, Harriss, Irby and Vose, was known as one of the largest cotton firms in the country. He served as Galveston's mayor in 1923 and 1924. (EV/GTHC.)

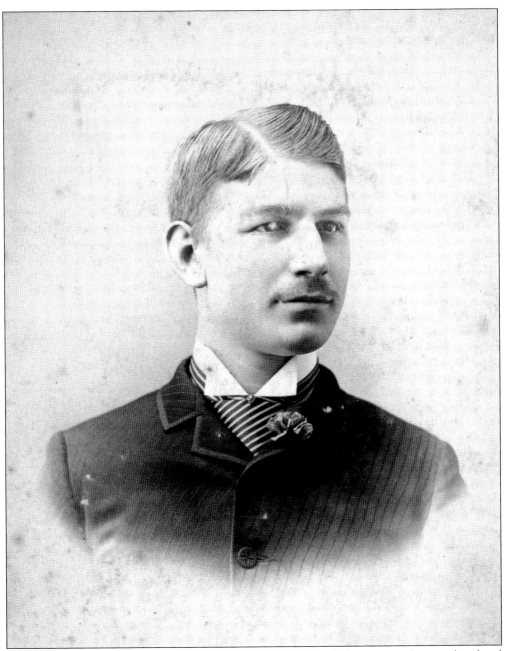

Dr. Nicholas Descomps Labadie (1802–1867) gave up his original plans to join the priesthood and became a respected doctor and pharmacologist. In 1831, he served as post surgeon at Anahuac. He also fought in the Battle of San Jacinto, where he interpreted Santa Ana's surrender to Sam Houston. After moving to Galveston in 1838, Labadie became the first practicing physician in the city, opened a drugstore, operated a mercantile and lumber business, and built and operated a line of schooners out of the Labadie Wharf. During the Civil War, he served as examining physician for draftees and as surgeon of the First Regiment, Texas Militia. He contracted a fatal bout of pneumonia while serving as part of the Texas Honor Guard for the mortal remains of Confederate general Albert Sidney Johnston. (CATH/GTHC.)

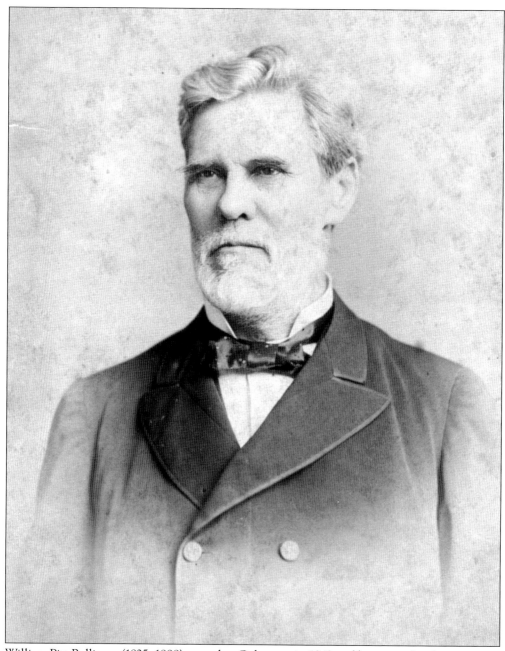

William Pitt Ballinger (1825–1888) moved to Galveston in 1843 and became a first lieutenant in the Mexican-American War in 1846. He was appointed adjutant of Col. Albert Sydney Johnston's 3rd Regiment of Texas Rifle Volunteers. By 1847, Ballinger received the first law license issued by the new state of Texas and joined a prestigious law firm in Galveston. He served as a US district attorney for Texas from 1850 until 1854, when he became a partner in a Galveston law firm with Thomas McKinney Jack and M.L. Mott. In 1861, Ballinger was appointed Confederate receiver charged by the Confederate District Court with seizing debts owed by Northerners. After the war, he declined appointments to the Texas Supreme Court in 1871 and in 1874 but participated as a member of the judicial committee of the Constitutional Convention of 1875. (EV/GTHC.)

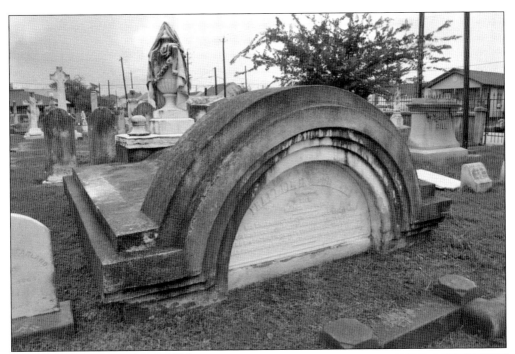

Franklin H. Merriman (1813–1871) was known for his intelligence and charming demeanor, and for commanding the respect of his opponents. Originally settling in Galveston as a farmer, he was elected US senator for Brazoria and Galveston Counties in 1851 and served until 1853. In 1866, Merriman won the position of Galveston County representative in the Texas legislature. His mausoleum has been largely covered by multiple grade raisings. (TE/KSM.)

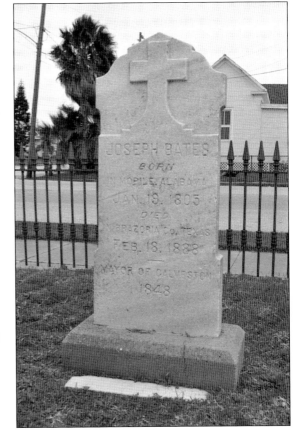

Joseph Bates (1805–1888) served as a major during the Seminole War of 1835, in between his four terms in the Alabama legislature. After moving to Galveston in 1845, he was soon elected mayor, then appointed a US marshal by Pres. Millard Fillmore. As a colonel in the Confederate army, he led Bates' Texas Infantry and was placed in command of coastal defenses between Galveston and Velasco. (TE/KSM.)

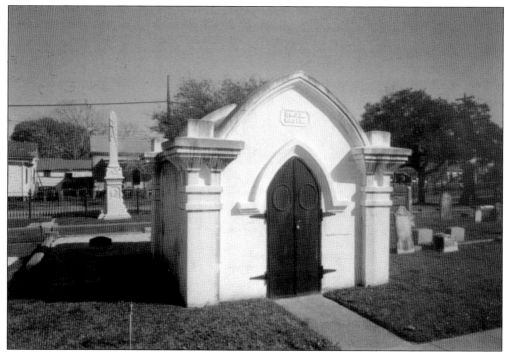

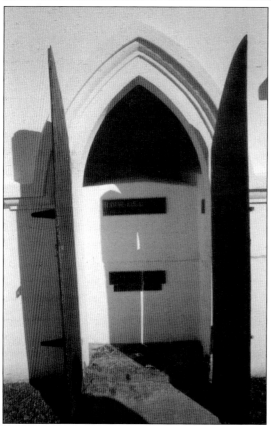

Dr. John Miller Haden (1825–1892) was a leader in the medical community of Galveston, and Pres. James K. Polk commissioned him as assistant surgeon in the US Army in December 1847. After the Mexican War, he remained in the Army as medical officer in the party that escorted the civil officials to the Oregon Territory. When the Civil War began, Haden entered the Confederate army medical corps, becoming chief of the medical bureau. He went to Galveston at the close of the war to practice medicine, and in 1873 the first board of trustees of the Medical Branch of the University of Texas appointed Haden to teach *materia medica* and therapeutics. He later served as president of the Galveston Board of Health. Several family members, including his wife, Sarah, and their granddaughter, actress Sara Haden, share the family crypt. (Both, TE/GTHC.)

Dr. Stephen Moylan Bird (1841–1894) was a rector of Trinity Episcopal Church for 22 years. The Virginia-born theologian was highly respected for his mission work in the community. In 1893, he received an honorary doctor of divinity degree from the University of the South in Sewanee, Tennessee. His first wife, John-Ann, mother of nine of his 10 children, is buried beside him. (TE/GTHC.)

Thomas Henry Borden (1804–1877) moved to Texas in 1824 as one of the Old Three Hundred original settlers of Austin's colonies and cofounded Houston's *Telegraph and Register* newspaper in 1835. Borden was the first builder of gristmills in Galveston, including his own on Post Office Street. Before dying of typhoid fever, he invented a steam gauge for boats and a sail car that raced along the beach. (EV/KSM.)

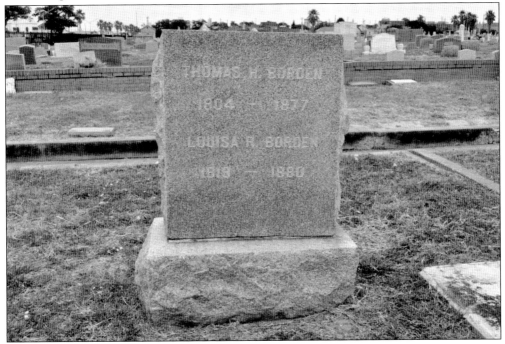

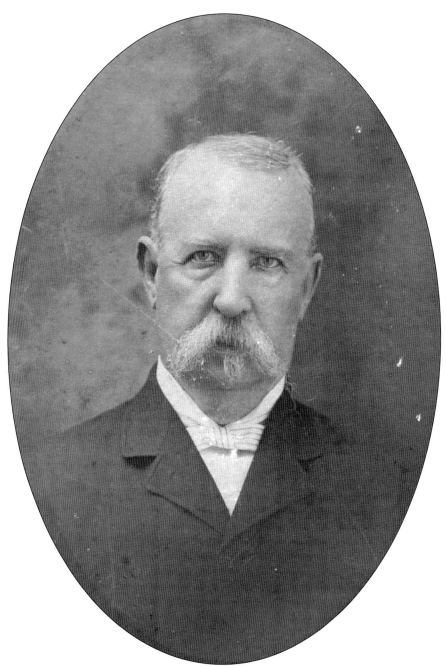

Robert Graham Lowe (1837–1906), a Scottish-born journalist, came to Galveston from Louisiana after fighting for the Confederacy. He began working at the *Galveston News* as a printer in 1874 and became managing editor by 1880. His concept for a Dallas edition of the paper became the *Dallas Morning News*. Lowe was vice president of both publications and the only officer of Belo Company who was in the state at the time of the 1900 storm. He supervised production of the local paper in the form of a handbill for four days until regular printing could resume. His writings immediately following the disaster were credited with playing a part in spurring the city into rehabilitation. (TE/GTHC.)

Lorenzo Clarke Fisher (1833–1906) served as a captain in the 7th Texas Confederate Cavalry Regiment. His later success as a commercial merchant provided him with the exposure to be elected mayor in 1881 and representative to the state legislature in 1884. Fisher corresponded with *Popular Science* in the 1880s, sharing keen observations about his surroundings such as the habits of imported ants and yellow fever theories. (NC/GTHC.)

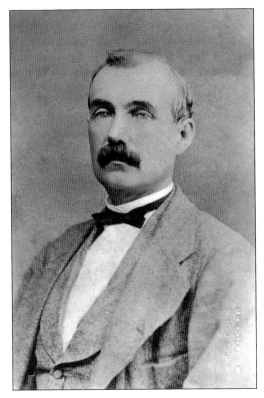

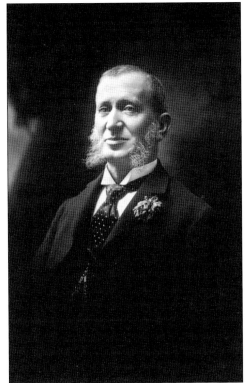

Isidore Lovenberg (1844–1917) was born in Paris, France, and immigrated to the United States at the age of 14. He moved to Galveston nine years later. An insurance agent by trade, Lovenberg was one of the organizers of Congregation B'nai Israel, on the board of the Galveston Orphan's Home, president of the Hebrew Benevolent Society, grand president of the local masons, and aided in obtaining a state charter for the Rosenberg Library Association. (HEB/GTHC.)

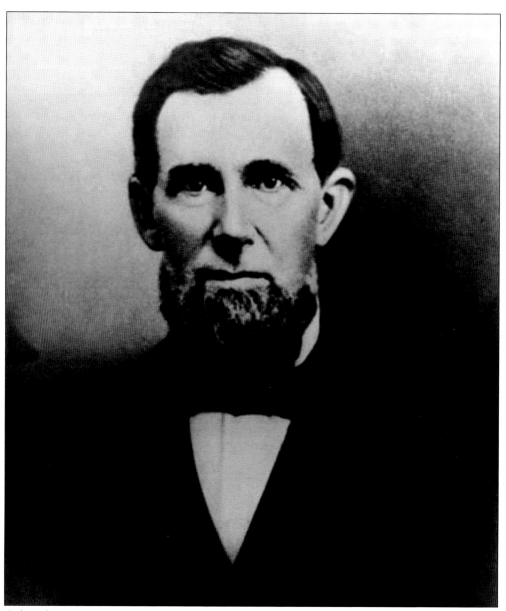

Col. Nahor Biggs Yard (1816–1889) came to Galveston from New Jersey in 1838 and formed a partnership running trade between vessels in the channel and the shore. Yard also assisted in organizing the Galveston Guards, one of the chief sources of reliance against Mexican invasion until annexation. In 1841, he opened a successful men's clothing store, Briggs and Yard, which he operated until his partner's death on the steamship *Varuna*. During the Civil War, Yard helped muster the Galveston Rifles and fought in the 1st Regiment, 1st Brigade, Texas State Troops. He was later president of the Howard Association, which acted as a relief organization during Galveston's 1867 yellow fever epidemic. Yard served as director and president of the Galveston Gas Company, treasurer of the Galveston, Houston & Henderson Railroad Company, and superintendent of public schools of Galveston County. He was one of the earliest masons in Texas and the oldest surviving past master of the Harmony Lodge. He also helped organize Hook and Ladder Company No. 1, the first fire company in Texas. (TE/GTHC.)

William H. Perrett Sr. (1852–1935) moved from Australia as a young man and worked with Galveston's mule-drawn streetcars, eventually driving the first electric car over the East Broadway route. In 1880, he began a law-enforcement career that would span 41 years, including eight as police chief. His patrol beats included Garten Verien and Union Station. Perrett was a member of Knights of Pythias and Woodmen of the World. (TE/GTHC.)

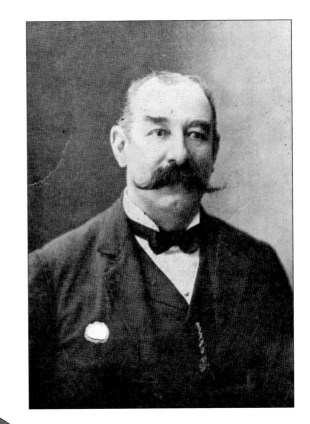

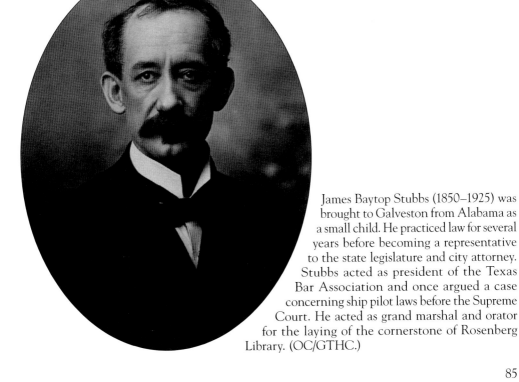

James Baytop Stubbs (1850–1925) was brought to Galveston from Alabama as a small child. He practiced law for several years before becoming a representative to the state legislature and city attorney. Stubbs acted as president of the Texas Bar Association and once argued a case concerning ship pilot laws before the Supreme Court. He acted as grand marshal and orator for the laying of the cornerstone of Rosenberg Library. (OC/GTHC.)

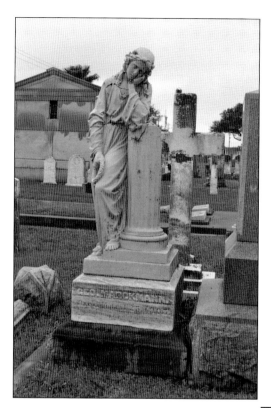

George Marckmann (1817–1905), the one-time mayor of La Grange, Texas, was born in Oldenburg, Germany, in 1813. He first settled in Vera Cruz, Mexico, after immigrating to America in 1849. While in that country, Marckmann formed the contacts he would later use to establish trade between Texas and Mexico during the Civil War as a commission merchant and manufacturer's agent in Galveston. (TE/KSM.)

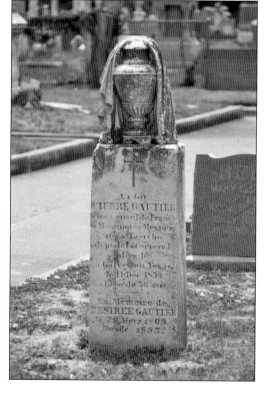

Pierre Gautier (1783–1859), French vice consul at Matamoros, Mexico, was born in Uzerche, Correze, France. He and his wife, Desiree, their two children, and four Mexican servants were issued a letter of safe passage signed by Sam Houston when they moved from Matamoros, Mexico, to San Luis Island in 1842. He was one of the original stockholders of the Brazos & Galveston Railroad Company. (OC/KSM.)

Four

ALL WALKS OF SOCIETY

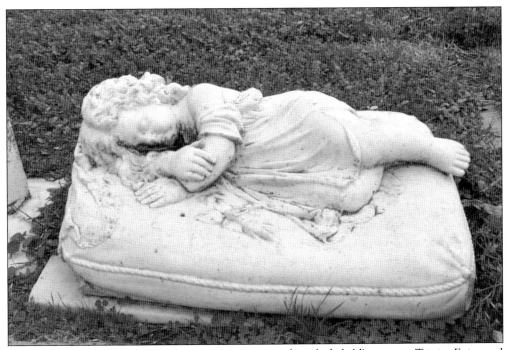

This exquisite sleeping child sculpture sits atop an unidentified child's grave in Trinity Episcopal Cemetery. (TE/KSM)

Charlotte Walker (1876–1958) was a Galveston-born actress who made her debut at the age of 17 in London. She married Dr. John B. Haden but returned to the stage after the 1900 storm. Walker appeared in several silent films, including Cecil B. DeMille's 1916 *Trail of the Lonesome Pine*, as well as numerous Broadway plays. Her daughter Sara Haden also became a well-known actress. (TE/KSM.)

James "Shorty" Grice (1879–1932), known as Shorty by fishermen throughout south Texas, ran a modest bait and tackle shop that became an institution. After arriving from Liverpool, England, he observed that many recreational fishermen forgot to bring bait and opened a shop to provide this necessity. He slept in the back of his store and could be roused for a sale at any time of the day or night. (OC/KSM.)

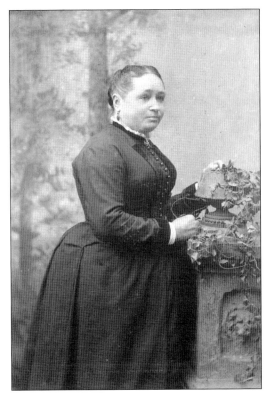

Wilhelmina Bautsch (1844–1934), a native of Germany, suffered the effects of a wild and unruly period in the city of Galveston. Her husband, Henry Bautsch Sr. (1839–1907), a well-known and respected building contractor and city appraiser, was murdered outside of Martini's saloon in a random act of violence by two intoxicated men. Their son Julius H. Bautsch (1876–1909), pictured below, testified at the murder trial as the witness to his father's last moments after arriving home fatally wounded. Julius passed away just two years after his father. (Both, NC/GTHC.)

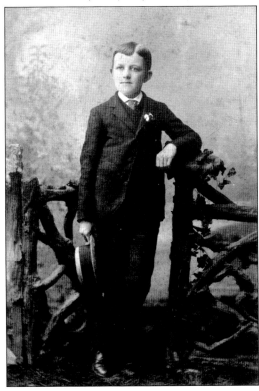

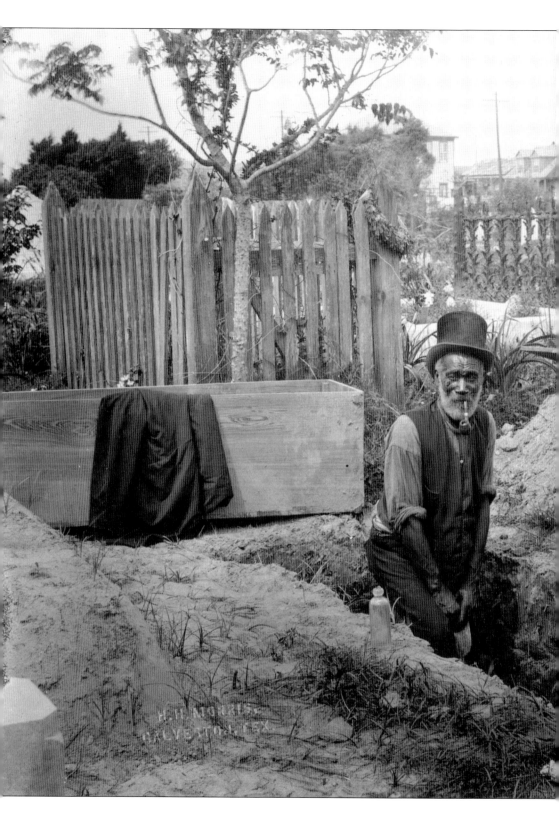

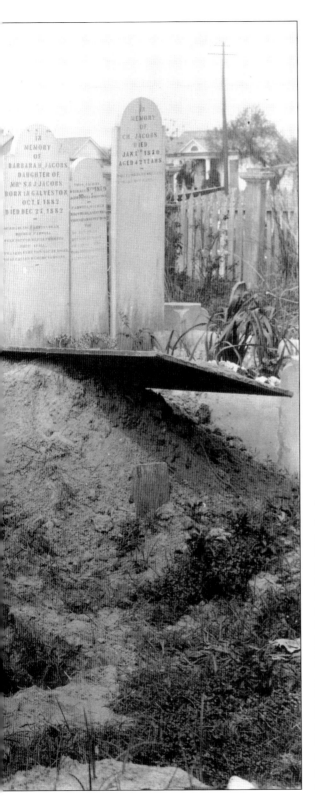

"Uncle" Newton Taylor (c.1828–1905) worked for Trinity Episcopal Church as an organ blower and gravedigger. He was easily recognized by his ever-present tall silk hat, underneath which he carried a plate of fried chicken for his lunch. Loved by all ages and classes of Galvestonians, he could often be found amusing young and old passersby with sleight-of-hand tricks. Also known to locals as "Old Doc" Taylor, he was described as being sedate and dignified. He dug the final resting places of hundreds of citizens and attended their graveside services. Although he claimed to be 78, many locals suspected him to be more advanced in age, despite having the energy of a young man. (CATH/GTHC.)

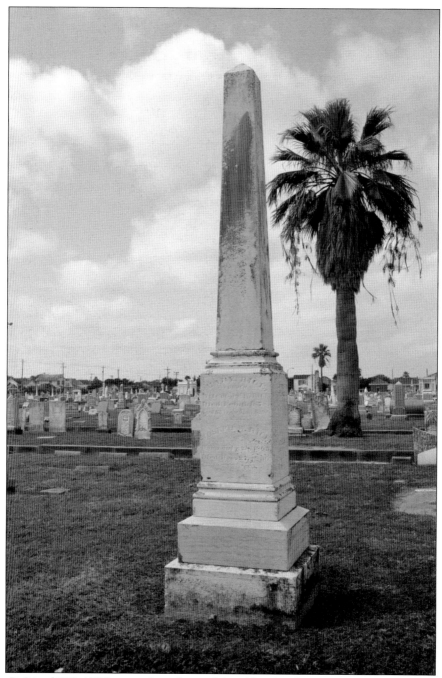

Louisa B. Rice (1839–1893), a member of one of the oldest families in Galveston, walked directly in front of an electric motor of the street railway and was run down. The driver of the car did not slow down because he was sure that she would hear the loud railcar approaching. He had no way of knowing that Rice was profoundly deaf. Beside her is her sister Mary Rice (1844–1921), who was a secretary and volunteer at the Lasker Home for Homeless Children. They are buried with several siblings and their parents, Joseph William Rice (1805–1890), a paint store owner, and Mary Rice (1811–1878). (OC/KSM.)

Elizabeth Percival (1843–1881), born in England, operated a successful boardinghouse and restaurant called the English Kitchen. On March 2, 1881, she and her stepdaughters, Florence and Jessie, invited friends to watch the passing Mardi Gras parade from her gallery. Her alcoholic ex-husband Richard Stephens mingled in the crowd of the enormous procession and shot her as he passed the restaurant, in front of numerous witnesses. (TE/KSM.)

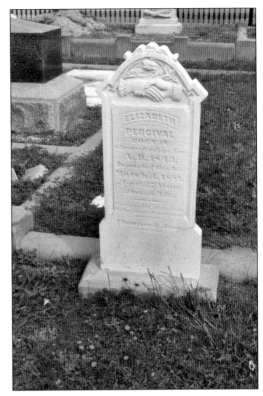

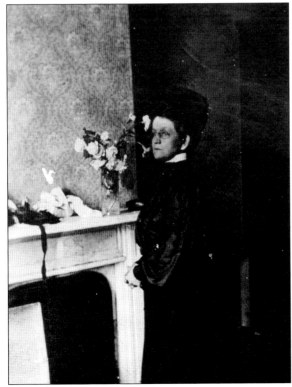

Maria Cage Kimball (1844–1911), a professional artist, joined Betty Ballinger and Lucy Ballinger Mills to form the city's first literary women's club, the Wednesday Club, which evolved into the Daughters of the Republic of Texas. Known as one of the most gifted artists of her day, Kimball studied in the principal cities of Europe. She taught art and was a contributing writer to the *Gulf Messenger* magazine. (NC/GTHC.)

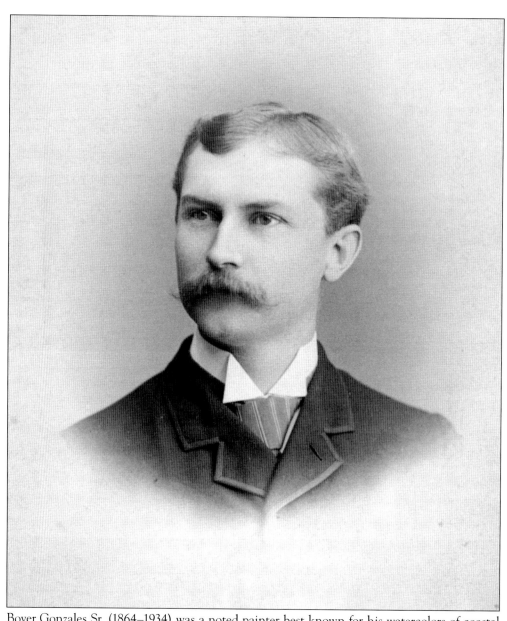

Boyer Gonzales Sr. (1864–1934) was a noted painter best known for his watercolors of coastal scenes of Texas and Maine. Born into a socially prominent Galveston family, he left the cotton business to pursue his love of art. A friend of Winslow Homer, Gonzales studied throughout Europe and the United States, and in 1904 was invited to show in the Texas Pavilion at the St. Louis World's Fair. He won medals for work exhibited in Dallas in 1921 and 1924 and a prize at the 1926 Southern States Art League competitive exhibition. Gonzales's work was exhibited at the Fort Worth Museum of Art, the Galveston Art League, and the Houston Fine Arts Museum. Solo exhibitions of his work were mounted by the Witte Museum in 1927 and 1936. The Rosenberg Library of Galveston owns over 200 of Gonzales's paintings, including one of his best-known works, *The Dawn of Texas*. His work is also included in the collections of the Modern Art Museum of Fort Worth, the New Orleans Museum of Art, and the Vanderpoel Art Association in Chicago. (TE/KSM.)

Matilda Ella "Tillie" Brown Sweeney (1865–1926) was a daughter of the prominent Brown family of Galveston. After her divorce from Thomas Sweeney, she and her three children moved into her parents' home, Ashton Villa. Known for her generosity, she was a board member of the Letitia Rosenberg Home for Women, an active member of the Trinity Episcopal Church, and a contributor to the collections of the Rosenberg Library. (TE/KSM.)

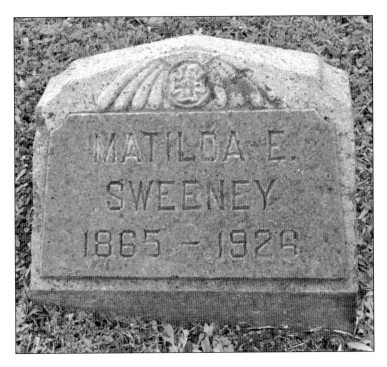

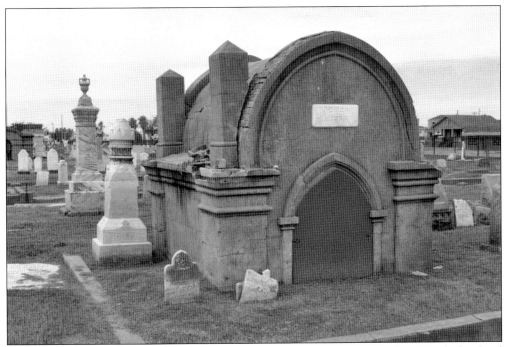

George C. Rains (1817–1888) established a popular saloon in the 1830s on the central wharf and operated it until his death. Originally called the Gem and renamed the Last Chance Saloon, it was a seafarer's first and last chance for a drink coming into and leaving port. He kept a curiosity shop at the back of the bar where old-timers shared stories from their adventures. (OC/KSM.)

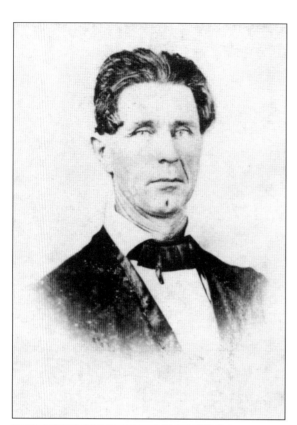

Gilbert Winne (1815–1860), an early settler in Galveston, came from New York by ship as a young man. He owned one of the first livery stables in town, located on Avenue G. The same street was later named Winnie after him. Winne secured a government contract to carry mail to the interior of Texas via horse, and died from injuries suffered in a carriage accident. (TE/GTHC.)

Missouri Pinckney Fannin (1829–1847) was the daughter of Texas hero Col. James Fannin. She and her mentally handicapped sister Minerva moved to the home of Thomas McKinney after losing both of their parents within two years, when she was only nine years old. Less than 10 years later, Missouri died of yellow fever during one of Galveston's outbreaks, leaving Minerva alone with the McKinneys. (TE/GTHC.)

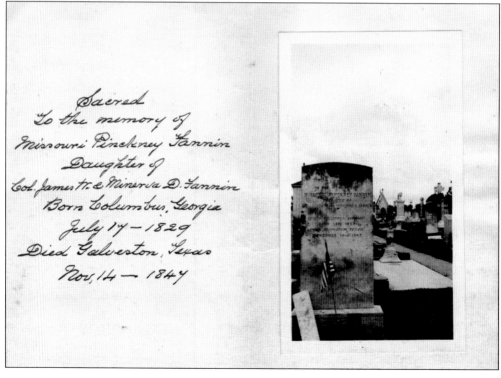

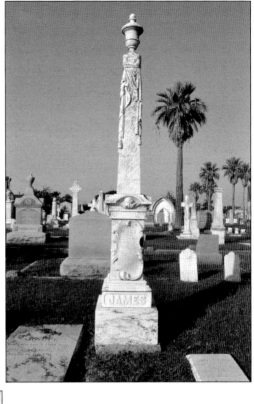

Alfred F. James (1813–1861) and his wife, Maria (1815–1886), immigrated to Galveston from England in 1836. A successful real-estate broker and public official, he was also a one-time president of the Galveston, Houston & Henderson Railroad, a director of the Galveston Wharf Company, and an organizer of the Galveston Gas Company. Their son Michel Branamour Menard James (1851–1906), the youngest of eight, was named after the city's founder. Although he worked as a bookkeeper in his early years, by the age of 18 he was diagnosed as insane and confined to the Austin State Lunatic Asylum for the last years of his life. (TE/KSM.)

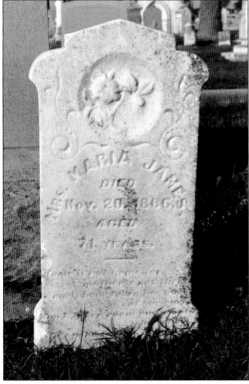

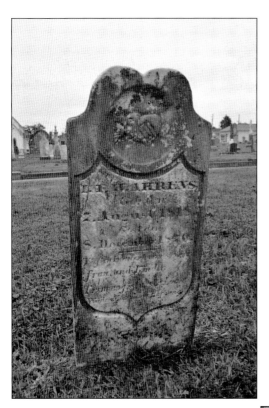

I.F.W. Ahrens (1818–1870) emigrated from Germany to Galveston in 1847 and began a successful business manufacturing saddles, harnesses, furniture, and cabinets. He was elected a city alderman in 1866. Ahrens was also a volunteer member of the Star State Steam Fire Company No. 3, whose original firehouse on Church Street was lost in the 1900 storm. (OC/KSM.)

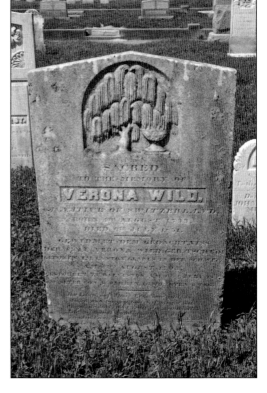

Verona Wild (1793–1851) and her husband, Samuel, immigrated from Canton Glarus, Switzerland, to Philadelphia, Pennsylvania, in 1830. Just three years after they arrived, she became a widow. Five years after her spouse's death, she bravely moved with her children to the new city of Galveston in the Republic of Texas to begin a new life in 1838. (OC/KSM.)

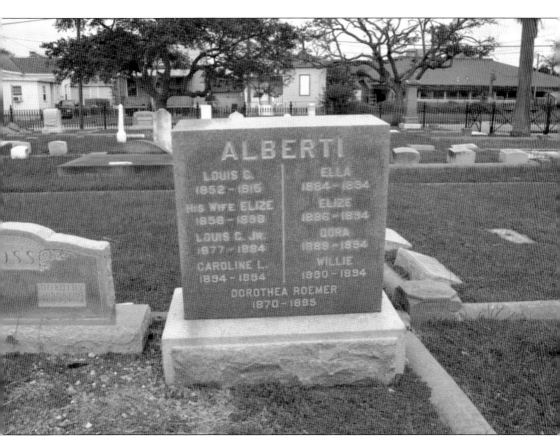

The Alberti family marker is unarguably the most tragic monument in the Broadway cemeteries. Galveston native Elize "Lizzie" Roemer Alberti (1858–1898), wife of local butcher Louis G. Alberti (1852–1915), was under a great mental strain after losing her son Louis Jr. (1877–1884) to lockjaw and then infant daughter Caroline (1894–1894). She began to "act queerly" and was observed to have violent outbursts. On a Tuesday evening, while her husband was at work next door, she served sips of poisoned wine to her children, believing that they would be "better off." Willie (1890–1894), Dora (1888–1894), Ella (1884–1894) and Lizzie (1886–1894) all passed away in great pain within hours, despite the efforts of family members and a doctor. Their sisters Emma and Wilhelmina escaped their siblings' fate. The mother was taken to a mental hospital in San Antonio but released in 1898. Within a few months, she committed suicide by morphine and was buried with her beloved children. Her younger sister Dorothea Roemer (1870–1885) died of lung congestion only a year after the tragedy and shares their resting place. (TE/AC.)

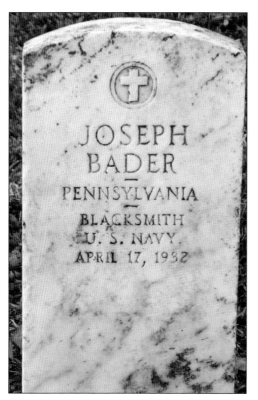

Joseph Bader (1881–1932) served in the US Navy as a blacksmith. After returning to Galveston he founded Vulcan Iron Works, which became known as the origin of the great fire of 1885 that destroyed 568 buildings on the island. After the disaster, Bader rebuilt his business and specialized in large sea vessel and oilfield equipment repair. He also manufactured the first motorized model airplanes. (CATH/KSM.)

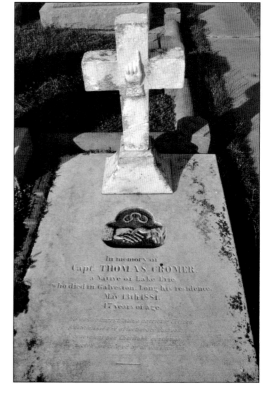

Capt. Thomas Cromer (1834–1881) spent his early life at sea but settled in Galveston by 1860. For many years, he served the community as the city marshal, enforcing the rulings of the local civil court system. At the same time, he owned and operated a saloon and boardinghouse on the Strand, which his wife, Caroline, ran alone after his death. (TE/KSM.)

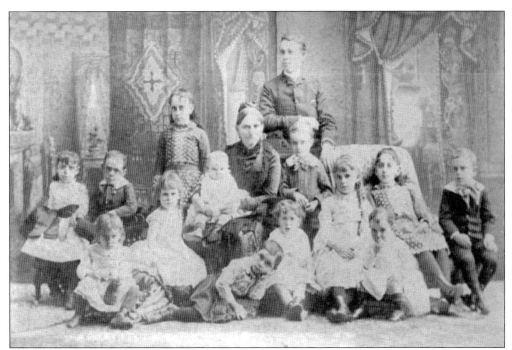

Isabella Offenbach Maas (1817–1891), an opera singer from Cologne, Germany, was the sister of famous composer Jacques Offenbach. Her husband, Samuel Maas, first saw her while she was performing on a European tour. They married in Cologne in 1844 after a brief courtship and returned to his home in Galveston. The singer survived being stricken with yellow fever and became active in many civic and charitable organizations. She continued to sing opera for family and friends, especially at her son Max's home, where a special stage had been built for her. After having four children together, the Maases separated, and the singer moved into her daughter's home, where she lived for almost 40 years. That home at 1727 Sealy Avenue has obtained a Texas State Historical Marker as the performer's residence. She is pictured here surrounded by her grandchildren. (Above, Cannon; right, HEB/KSM.)

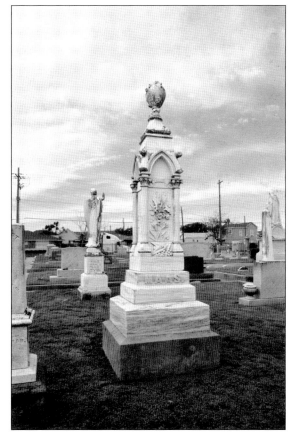

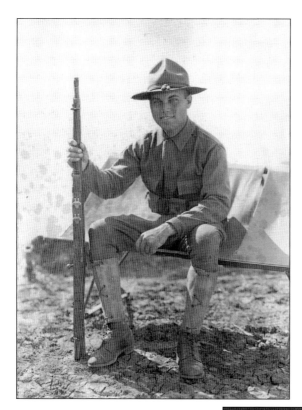

Justus Arthur Guthrie (1889–1943) was a veteran who served in France during World War I in the Army Coast Artillery corps on an ammunition train. The handsome Dallas bank clerk never married and spent his later years supporting his mother and, at times, his sisters. (OC/Scott.)

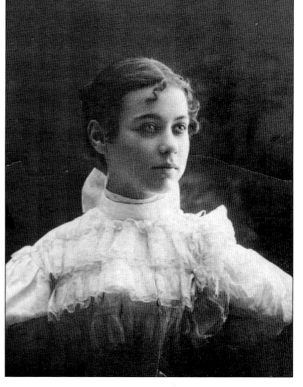

Agnes Elizabeth Guthrie (1880–1899), a popular musician at St. Paul's German Presbyterian Church, was one of Galveston's well-educated young beauties. Her journal, now owned by a family member, includes entries about the suspicious fire that destroyed the renowned Beach Hotel. She died of acute appendicitis at age 18. (OC/Scott.)

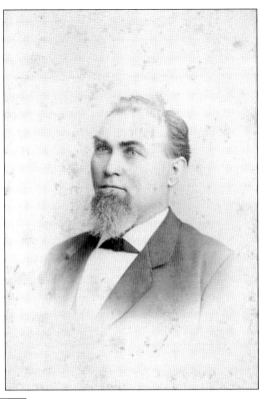

Capt. David Guthrie (1836–1891) immigrated from Elie, Fife, Scotland, to Galveston where he became one of the few registered bar pilots on the island. In 1871, he married Antoinette Caroline Costard (1859–1928), who immigrated to the city with her mother, Elizabeth Barbara Hausinger Costard (1824–1884), aboard the ship *Erna* from Hamburg, Germany. Together, they had six children: Rosalie, Agnes, Bertie, Edna, David Jr., and Justus. Four of these lived to adulthood, and only three ever married. The majority of the family shares a single granite obelisk grave marker. (Both, OC/Scott.)

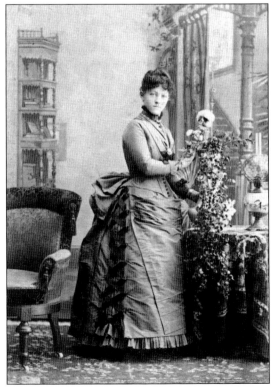

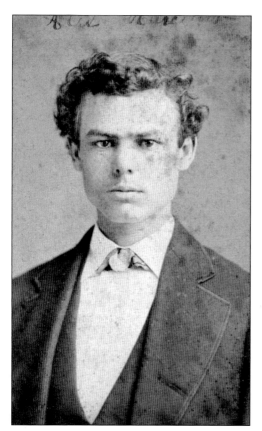

Alexander C. Harcourt (1856–1882) left with a group of friends for a duck-hunting expedition to Beaumont. Mysteriously, no one in the group noticed until they returned home the next morning that Harcourt was missing. The Galveston paper reported two conflicting versions of what the search party found: he was in a swamp and had accidently shot himself, and he was found dead from congestion in an open prairie. (EV/GTHC.)

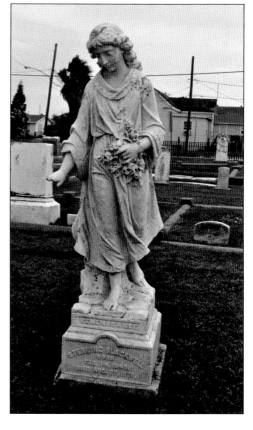

Sterling Blackwell (1843–1870) was born to Sally Ann and Thomas Blackwell, who divorced. Blackwell claimed Sterling was not his child, and Sterling McNeel adopted him at age seven at his mother's request. He became the sole heir of the Darrington Plantation in Brazoria County, which he owned only for a short time before his death from lung disease. The land is now part of the Darrington Prison Unit. (TE/KSM.)

William Wright (1818–1881) was an enterprising real estate man who built one of the first three-story brick buildings on the island in 1873. Situated on the southwest corner of Market and Twenty-first Streets, it marked the beginning of the replacement of existing shanties. Wright was also the treasurer of several large, local cotton corporations and was an active member of the volunteer Island Steam Fire Engine Company, organized in 1856. (TE/KSM.)

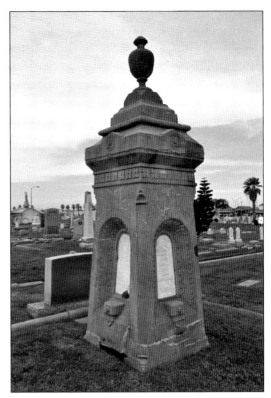

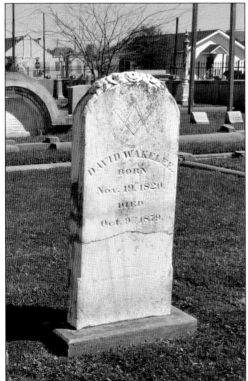

David Wakelee was a ship's chandler who operated from his workshop on the Strand. He held the office of city treasurer for several years, and served as the vice president of the Howard Association. His grave marker features two symbols of masonic membership: the traditional compass and square, and a keystone marking a fourth degree mason featuring an abbreviation of the sentence "Hiram the Widow's Son Sent to King Solomon." (TE/KSM.)

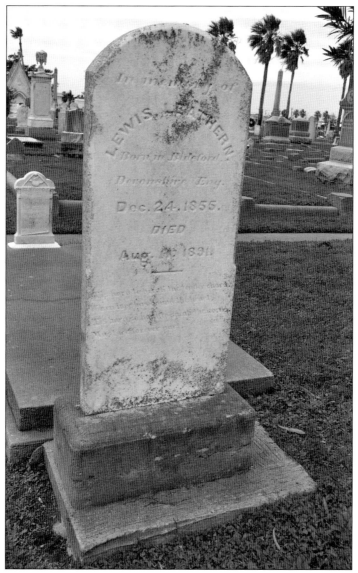

Lewis Leathern (1855–1891), a dry goods store owner, died of five stab wounds inflicted by his former brother-in-law, Clemens David Aull. Leathern made a statement as he lay dying that he did not want Aull charged with his death. He asserted that if he had not gone to Aull's home to begin a quarrel and physically attacked him, the injuries never would have happened. Leathern, who was much larger than his brother-in-law, had arrived at Aull's home at 9:30 at night, knocked him to the ground, and inflicted a gash above his eye. The reason for the dispute was never revealed. Leathern had been divorced by his wife, Mary Elizabeth Aull, in December 1890, and she moved to California with their children. His epitaph seems to refer to the loss of his marriage as well as his life. (TE/KSM.)

'Tis hard to break the tender cord,
When love has bound the heart,
'Tis hard, so hard to speak the words,
Must we forever part?

Five

STONE MASONS AND FUNERAL HOMES

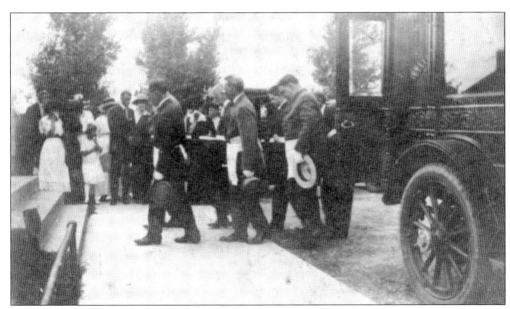

Before funeral homes became commonly available, visitations and funerals were traditionally conducted at the deceased's home. (GTHC.)

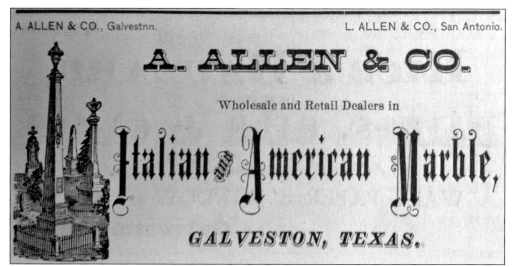

A. ALLEN & CO., Galvestnn.

L. ALLEN & CO., San Antonio.

A. ALLEN & CO.

Wholesale and Retail Dealers in

Italian and American Marble,

GALVESTON, TEXAS.

Alexander A. Allen founded the state's first marble works in 1852, located on Center Street between Strand and Mechanic Streets. He took young stonecutter Charles Sebastian Ott into partnership 25 years later, and after Allen's death, Ott purchased the business from Allen's wife, Elizabeth, changing the name to Ott Monument Works. (GTHC.)

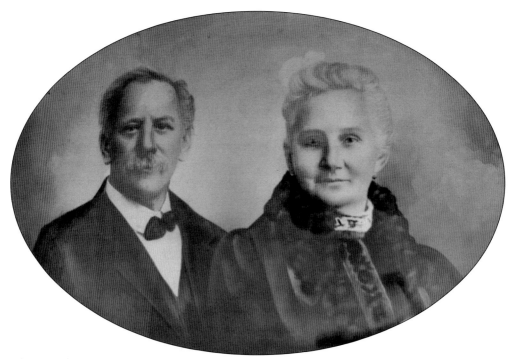

Charles Sebastian Ott, pictured here with his wife, Ellen Agnes O'Reilly, was born to German parents in Louisville, Kentucky, in 1847. In 1877, the expert stonecutter brought his wife and children to Texas and worked for two years on the ornate stonework of the post office being built in Austin. In 1879, they moved to Galveston, and he began work carving tombstones and ornamentation for several major city landmarks. (Ott.)

Ships from Europe carried marble for ballast. As they unloaded thousands of tons at Galveston docks, it was sold far below the cost of American marble. This explains the abundance of the otherwise expensive stone in local cemeteries. Ott was also the first monument works in Texas to use Eastern granite for his creations due to the availability of ballast from New Hampshire. (OC/KSM.)

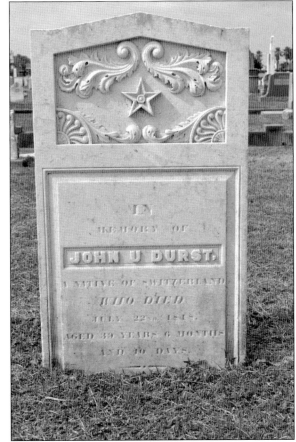

Three of C.S. Ott's daughters became nuns at the Ursuline Convent. Ott presented the convent with statues of Carrara marble portraying the Virgin Mary, St. Joseph, St. Theresa, and St. Ignatius. They flanked the grand staircase on the north side of the building until they were lost in the 1900 storm. (GTHC.)

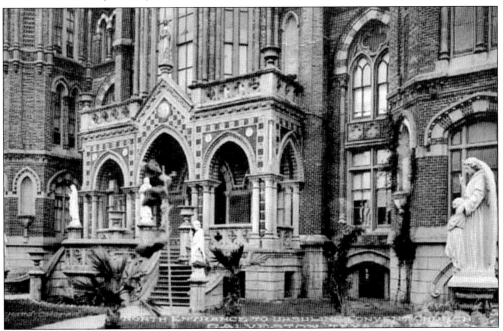

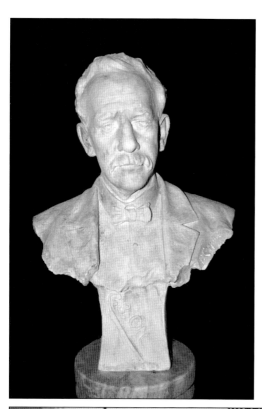

In addition to the skills of C.S. Ott, the Broadway cemeteries contain the artwork of local stonemason Joseph Tickle, who worked for Ott, and European craftsmen brought to town for special projects such as elaborate mausoleums. When famed sculptor Pompeo Coppini was in Galveston to execute a commission, he created this bust of Ott as thanks for allowing him to utilize a work area with the business. (KSM.)

John Charles Ott, born in 1876, learned much of the art of stonecutting from his father, Charles. He established his own monument works in Beaumont but returned to Galveston after the 1900 storm. When his father died in 1909, he took over the family business. (GTHC.)

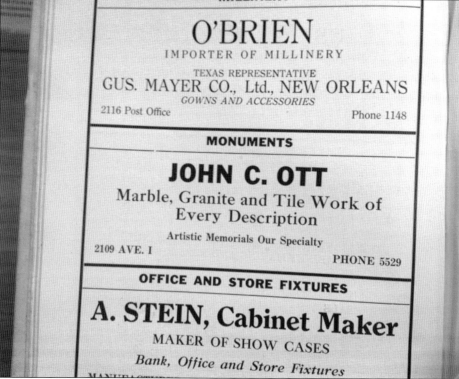

Bernard E. Ott, pictured here by one of his great-grandfather Charles Sebastian's monuments, is the fourth of five generations to own Ott Monument Works. The base of this granite memorial is unique in that it features the signature of C.S. Ott, who rarely signed his creations. The marker is that of O.C. Hartley (1828–1858) and family, and is over 25 feet in height. The separate pieces that make up the monument were individually lifted into place one by one with a gin pole, which is a rigid pole system secured with multiple guy wires and used for raising heavy objects. (Both, TE/KSM.)

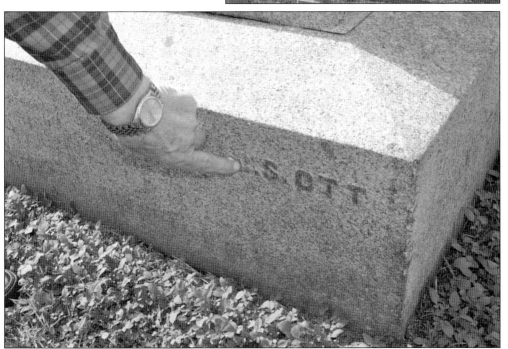

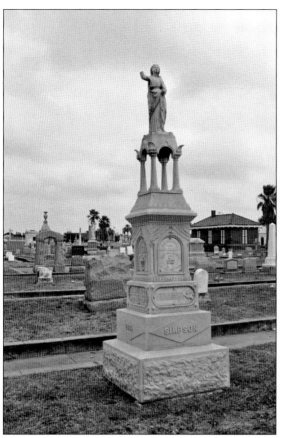

Zinc markers, often referred to as white bronze, were a popular alternative to marble and granite because of their promise to last longer than natural stone. Only produced for 40 years, between 1874 and 1914, they were ordered through catalogs or storefronts like the one in Galveston. White Bronze Monuments Company on Twenty-second Street was only listed in local directories for the year 1885. With the onset of World War I and the government's need for zinc, the industry died. Zinc monuments, which are neither white nor bronze, are known for maintaining clear lettering and motifs over long spans of time. Pictured here are the grave markers for Charles Kohl Simpson (1821–1884) in Evergreen Cemetery and the monument company logo on the marker for Dr. Jonathan Lewis Large (1826–1881) in Trinity Episcopal Cemetery. (Both, KSM.)

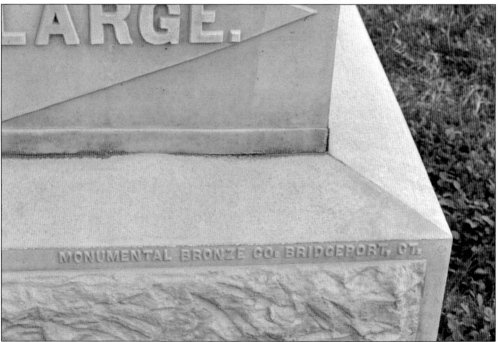

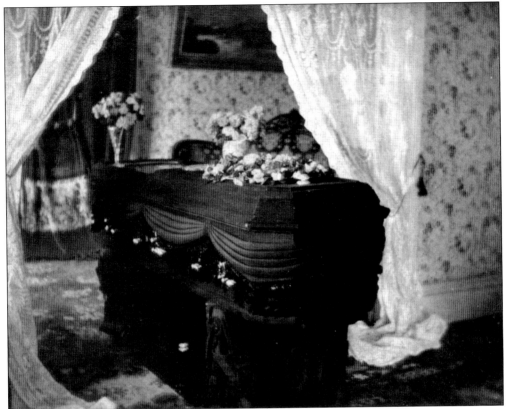

Prior to the Civil War, most American families cared for their own dead, dressing and preparing them for visitation in the front parlors of their homes. The departed would then be transported directly from the home to a burial site. With embalming becoming a necessity to return loved ones home from the war, the new business of undertaking became popular, often evolving from existing livery stables, which had transportation capabilities. (GTHC.)

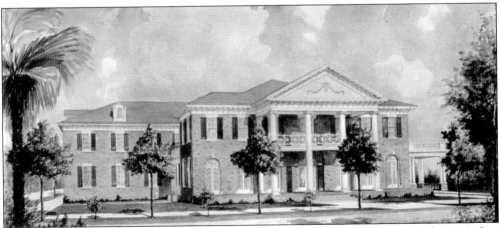

In 1902, English immigrant Frank P. Malloy established a livery stable with Galveston's first horse-drawn ambulance service as well as a funeral business. He added the city's first automobile ambulance in 1909. In 1930, Malloy & Son Funeral Home built its beautiful new facility on Broadway, now operated by the fifth generation of the Malloy family. (Malloy.)

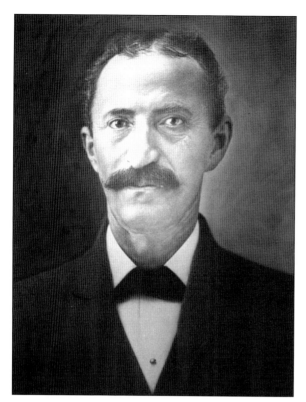

Joseph and Bernard Levy, immigrant brothers from Alsace, France, founded J. Levy and Brothers livery business in 1868. They bought, rented, and sold horses and rented and sold buggies. Eventually adding the service of funeral transportation, they expanded into the undertaking business by the end of the 19th century. Bernard (1850–1908), pictured at left, died aboard the SS *Frankfort* off the coast of La Corona, Spain, where he had traveled for his health. Joseph (1844–1922), pictured below, retired shortly afterward, and they are buried in Hebrew Benevolent Cemetery. Their eldest sons continued the company, adding the city's first motorized hearses in 1916. The business was operated by three generations of Levys before being sold to the Termini family, which operates it today. (Both, GTHC.)

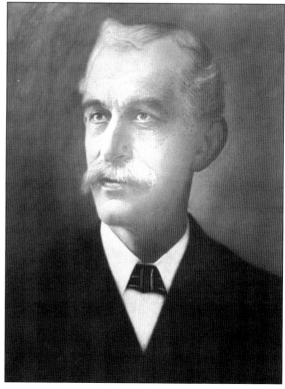

Six

EFFECTS OF STORMS

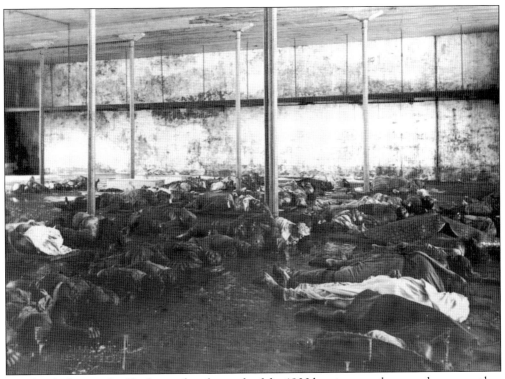

Faced with thousands of bodies in the aftermath of the 1900 hurricane, volunteers drove countless wagonloads of victims toward the Strand to be identified or disposed. (GTHC.)

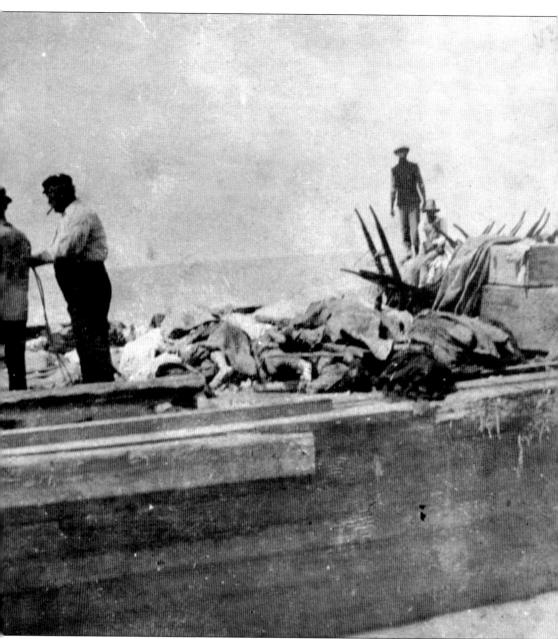

On September 8, 1900, Galveston was devastated by a hurricane that killed an estimated 8,000 people. Due to the overwhelming loss of life and shortage of resources, Galvestonians buried hundreds of victims where they were found or took them to the sand dunes for burial. Hundreds more were loaded in wagons and taken to cotton warehouses on the Strand to give citizens the chance to identify loved ones. After removing jewelry and personal items to assist later identification, 700 bodies were loaded on sea barges, weighted, and released overboard two days after the hurricane. Within 24 hours, bodies began washing back on shore. On September 11, the Central Relief Committee began overseeing the burning of bodies in funeral pyres amidst rubble all across the island. (GTHC.)

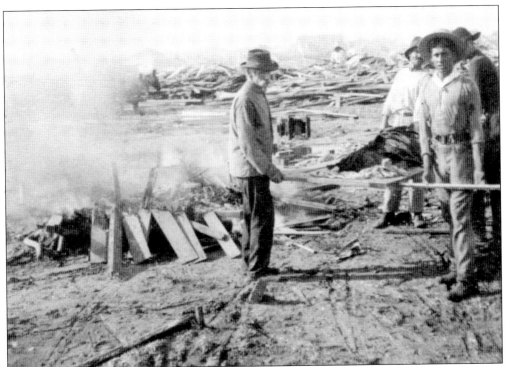

Entire families perished, and those who did survive were susceptible to malaria, dysentery, pneumonia, tuberculosis, and tetanus. The trauma led many to insanity and suicide. Emile Seixas lost his wife and four of his children, including 17-year-old daughter Cecile, who is buried with her family in Evergreen Cemetery. The work of recovering bodies lasted for months. The body of Lucy Klein Holbeck, who was interred in the Old City Cemetery on November 19, 1900, was one of those recovered and identified by two rings removed from her fingers. Even a year later, some victims remained interred in the yards of homes, much to residents' dismay. Many will never be found. A Galvestonian at the time lamented, "We have graves in our streets." (Above, GTHC; below, KSM.)

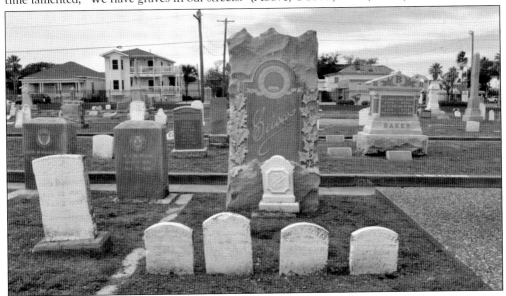

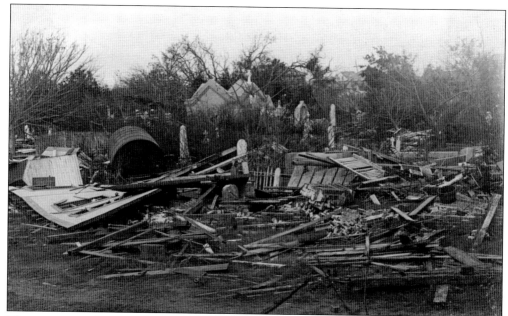

The storm surge disinterred many of those buried in the local cemeteries, and coffins were fished out of the water as far away as Texas City. Tombstones, fences, and monuments were scattered up to 100 feet. Reportedly all but a few of the previously buried were recovered and returned to their resting places, but with the fences down, wandering livestock roamed through the grounds, causing further damage. (GTHC.)

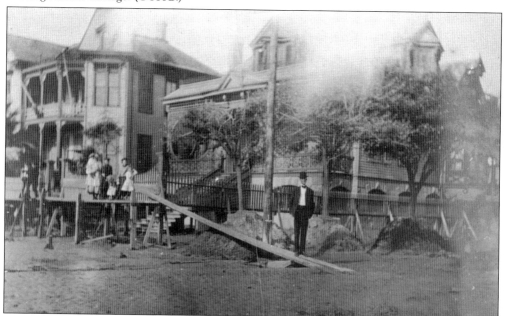

Determined to rebuild their city stronger than before, Galvestonians constructed a seawall and began the task of raising the grade of their island. Structures previously five to six feet above sea level were raised to heights of eight to 22 feet. Burial grounds were no exception, elevated three times between 1918 and 1925. These occasional adjustments are thought to have resulted in up to three levels of interments in the cemeteries. (GTHC.)

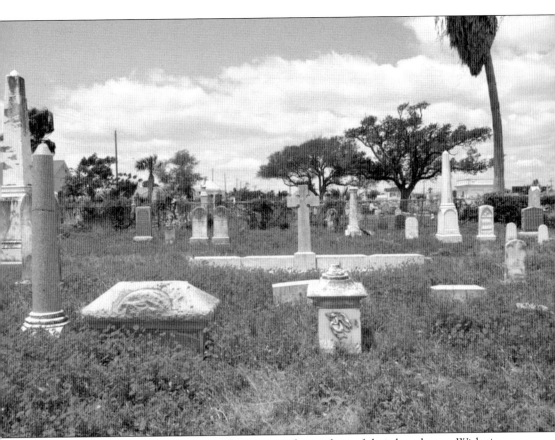

It was the financial responsibility of families to raise the markers of their loved ones. With times being hard and many families having moved away after the storm, only an estimated 25 percent of the markers on Broadway were raised. Only markers, not actual graves, were raised. Larger monuments and mausoleums purchased by some of the city's wealthiest citizens were declared too large to lift and were either partially or completely covered in the process. In the last grade raising in 1926, the cemeteries were elevated two to six feet. As each financed headstone was removed in preparation for the grade raising, the workers marked it with a number, stored it in an empty lot across the street provided by the Catholic church, and put a six-foot-long two-by-four marked with the name and number in its place. After the fill was complete, the stones were returned. (KSM.)

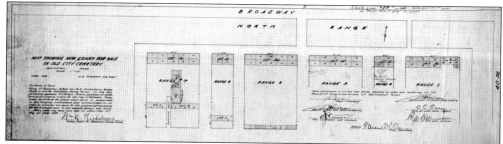

The newly unmarked sections were then subdivided and sold as new burial plots. Avenue K, which originally ran through the middle of the cemeteries, was narrowed to provide additional burial plots. This 1933 map shows some newly available plots where graves were previously marked. As new graves were dug, sextons often encountered buried wrought-iron fences and grave markers. (City of Galveston.)

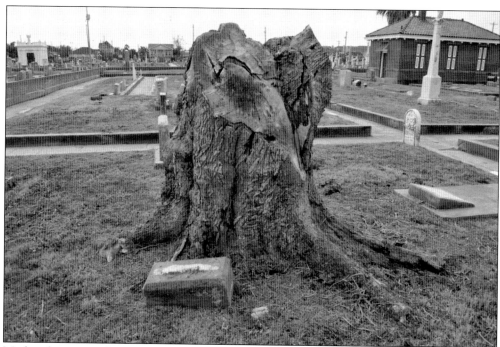

Modern hurricanes have caused their own damage as well. Galveston lost 35,000 trees during Hurricane Ike in 2008, including large, venerable oaks and oleanders in the city's cemeteries that were flooded with six feet of salt water. This loss drastically changed the appearance of the cemeteries. Winds also toppled a crucifix on top of the chapel in Old Catholic Cemetery. It was repaired and raised back into place in 2014. (KSM.)

Seven

RESTORATION AND RENEWAL

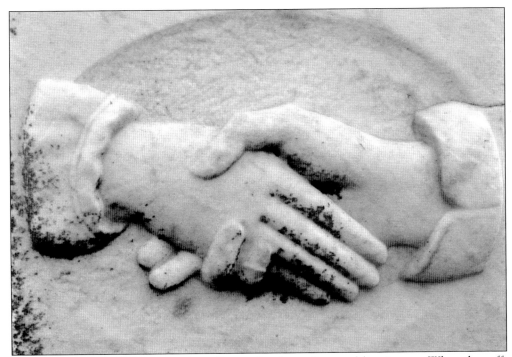

Clasped hands on a grave marker typically signify a farewell to earthly existence. When the cuffs visible at the wrists can be identified as clothing worn by a male and female however, it often symbolized a couple's reunion in the afterlife. (KSM.)

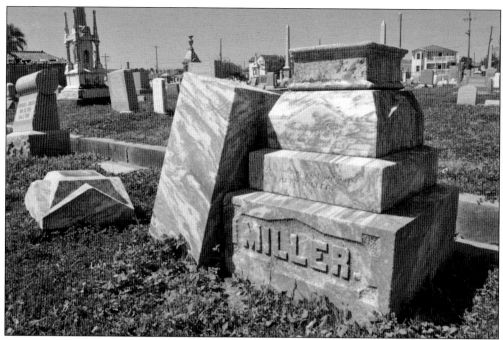

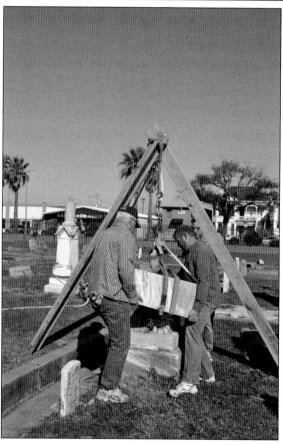

Settling ground, weather conditions, and even vandalism have toppled several of the larger monuments on Broadway. Much care is being taken to reassemble the structures, from leveling and compacting the soil to utilizing appropriate adhesive materials that will not damage the stones over time. Personal safety of workers is also a major factor, since the larger monuments can weigh several tons. Just one cubic foot of solid granite can weigh 168 pounds, and the same size in marble can weigh 160 pounds. (Both, EV/KSM.)

The City of Galveston and the
Friends of Galveston Cemeteries
organize occasional workdays
in which the public is invited
to participate. Expert guidance
and materials are provided to
train the volunteers for specific
tasks to ensure no damage is
done to the graves or markers.
Tasks can include bolstering
unstable stones, resetting
fallen monuments, removing
invasive plants, painting
woodwork, sweeping, picking
up trash, planting historically
accurate vegetation, and gently
cleaning surfaces. Participants
of every age and ability are
welcome. (Both, OC/KSM.)

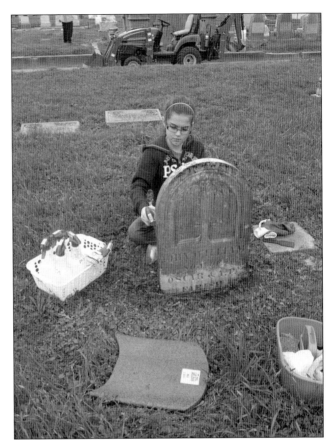

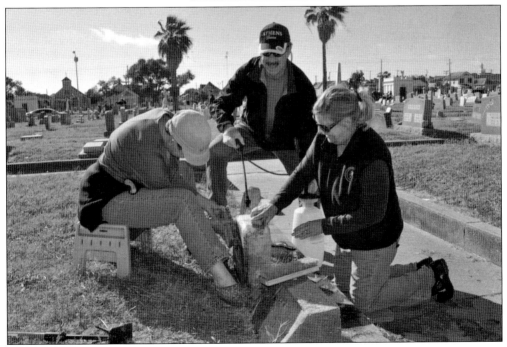

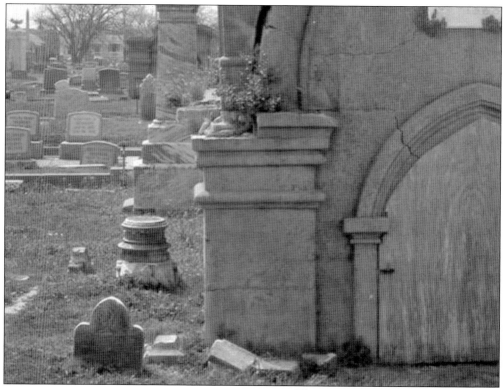

The monument of Maria Rains (1826–1890) is an impressive example of what can be accomplished by volunteers. Originally visible as only a small round stone next to her husband's mausoleum, her large grave marker was unearthed in a single day by a team of students from Galveston A&M University under the supervision of the city and historical officials. Each individually stacked portion had to be carefully lifted to the surface. The depth of the excavation also showed the original height of the neighboring mausoleum as well as her plot's original, intact wrought-iron fence, complete with finials, and the monument was reassembled at street level. (Both, OC/KSM.)

Once the sections of the Rains monument were lifted to the surface, the excavation site was refilled and leveled. Over the span of a few weeks, the earth settled and was ready to become a base for the structure. By carefully reassembling the stones, using stonecutter-grade epoxy when necessary, the memorial resumed its place above ground for the first time in a century. (OC/KSM.)

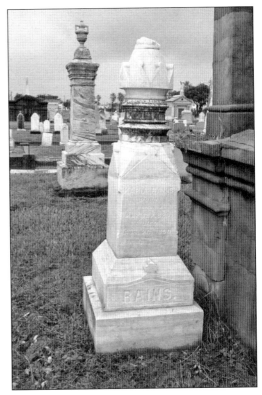

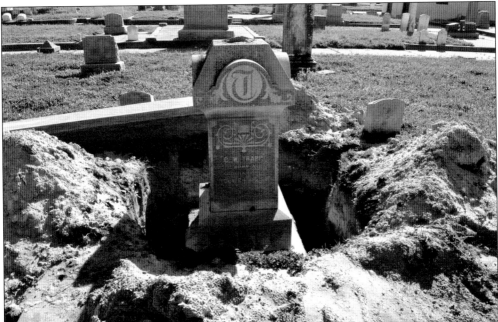

When visitors stop by the Broadway cemeteries, some plots may look a bit like an archaeological dig. The process of retrieving headstones and other markers that have been covered over time is a multi-step process that can last a few weeks for each project. Additional surprises are occasionally encountered, such as funerary items and adjacent smaller markers. (OC/KSM.)

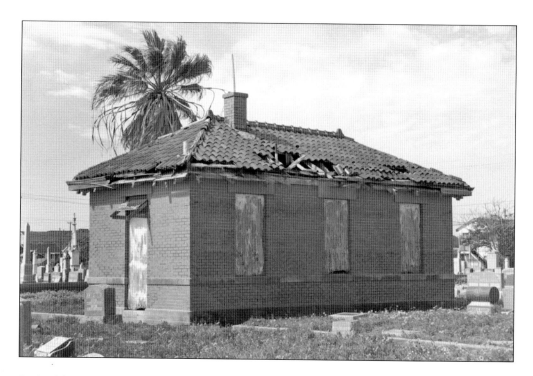

Both of the remaining brick buildings in the Broadway cemeteries are being restored for educational and utilitarian purposes. Rotten trim, timbers, and tile roofs have been replaced and the structures reinforced to last another 100 years. They originally served as sexton offices, with receiving vaults to store bodies until the time of burial. (Both, EV/KSM.)

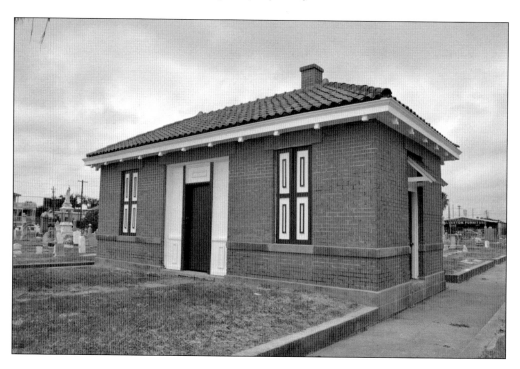

INDEX

Adoue, 37
Adriance, 47
Ahrens, 98
Alberti, 99
Allen, 63, 108
Armstrong, 20
Aull, 106
Austin, 32, 48
Ayers, 46
Bader, 100
Baker, 28
Ballinger, 78, 93
Bates, 79
Bautsch, 89
Bavoux, 52
Bird, 81
Blackwell, 104
Blamont, 71
Block, 50
Blum, 41
Borden, 81
Boyd, 59
Brown, 56, 57, 95
Burns, 28
Cahill, 2, 8
Caplen, 59
Chambers, 60
Cherry, 64
Chubb, 13
Coppini, 110
Cortes, 50
Costard, 103
Cromer, 100
Culp, 64
Davie, 40
Davis, 41, 57, 58
Day, 44

Dodridge, 16
Dowell, 72
Dunlevy, 21
Durst, 109
Dyer, 8, 10, 68
Fannin, 96
Farish, 71
Fisher, 26, 83
Fly, 65
Focke, 55
Fowler, 11
Franklin, 18
Gautier, 86
Gill, 58
Gonzales, 94
Grice, 88
Guthrie, 102, 103
Haden, 80, 88
Hall, 24
Harcourt, 104
Harris, 66
Harriss, 76
Hitchcock, 29
Hurd, 13
Hutchings, 51
James, 97
Jameson, 24
John, 16
Jockusch, 71
Joseph, 73
Journeay, 26
Kempner, 42
Kimball, 93
Kimble, 10
Kirkland, 56, 57
Kleinecke, 38
Knight, 73

Knox, 51
Kopperl, 33, 42
Labadie, 23, 77
Ladd, 37
Lasker, 39
Lea, 27
League, 49
LeClere, 55
Leathern, 106
LeCompte, 15
Levy, 54, 114
Lewis, 43
Love, 66
Lovenberg, 83
Lowe, 82
Lufkin, 38
Lynn, 68
Maas, 101
Mageean, 16
Magruder, 9, 19, 30
Malloy, 113
Marckmann, 55, 86
Marrast, 14, 59
Marx, 43
McCluskey, 61
McVitie, 53
Menard, 55, 67
Merriman, 79
Mills, 69, 93
Mott, 70, 78
Nichols, 30
Ohlendorf, 47
Osterman, 8
Ott, 108–111
Pearce, 76
Percival, 93
Perrett, 85

Perugini, 31
Pichard, 48
Pritchard, 21
Railton, 18
Rains, 95, 124
Reymershoffer, 49
Rice, 30, 92
Richardson, 74
Robertson, 17, 23
Robie, 15
Roemer, 99
Rubelmann, 49
Scrimgeour, 12
Sealy, 34
Seeligson, 52
Seixas, 117
Sherman, 20
Simpson, 112
Sonnenthiel, 54
Stubbs, 85
Sweeney, 95
Taylor, 90, 91
Temple, 44
Thompson, 74
Tickle, 110
Trueheart, 45, 47
Tucker, 22, 23
Ujffy, 58
Wakelee, 105
Walker, 62, 88
Wigfall, 25
Wild, 98
Williams, 45, 75
Willis, 34, 35, 36
Winne, 96
Wright, 105
Yard, 84

DISCOVER THOUSANDS OF LOCAL HISTORY BOOKS
FEATURING MILLIONS OF VINTAGE IMAGES

Arcadia Publishing, the leading local history publisher in the United States, is committed to making history accessible and meaningful through publishing books that celebrate and preserve the heritage of America's people and places.

Find more books like this at
www.arcadiapublishing.com

Search for your hometown history, your old stomping grounds, and even your favorite sports team.